IMAGES
of America

CHICAGO'S 1893 WORLD'S FAIR

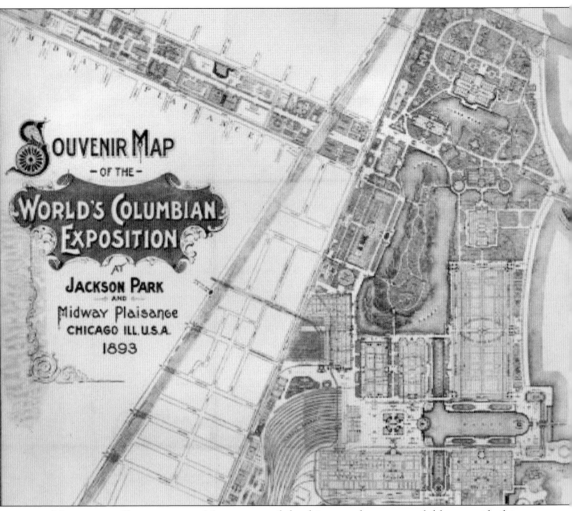

Souvenir Map
- OF THE -
World's Columbian Exposition
AT
Jackson Park
AND
Midway Plaisance
CHICAGO ILL. U.S.A.
1893

MAP OF THE FAIRGROUNDS. Many maps of the fairgrounds were available to guide fairgoers to the exhibits and other attractions on the 633 acres of the fair. The folded maps were small enough to be carried in a pocket and included numbered keys indicating the location of the Great Buildings, other major sites and exhibits, the Foreign and State Buildings, and the midway. (Library of Congress.)

ON THE COVER: SOUTH CANAL. Pictured is a view of the South Canal looking northwest from the Obelisk. (Library of Congress.)

IMAGES
of America

CHICAGO'S 1893
WORLD'S FAIR

Joseph M. Di Cola and David Stone

ARCADIA
PUBLISHING

Published by Arcadia Publishing
Charleston, South Carolina

Printed in the United States of America

Library of Congress Control Number: 2012941487

For all general information, please contact Arcadia Publishing:
Telephone 843-853-2070
Fax 843-853-0044
E-mail sales@arcadiapublishing.com
For customer service and orders:
Toll-Free 1-888-313-2665

Visit us on the Internet at www.arcadiapublishing.com

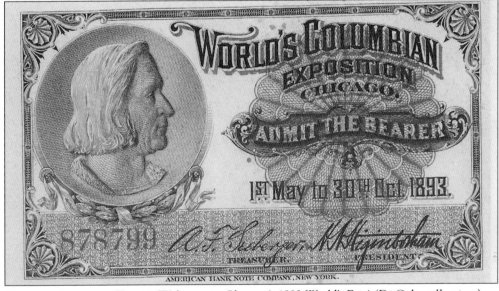

GENERAL ADMISSION TICKET. Welcome to Chicago's 1893 World's Fair! (Di Cola collection.)

CONTENTS

ACKNOWLEDGMENTS

Sell the cookstove if necessary and come. You *must* see the fair.
—writer Hamlin Garland to his parents living in Wisconsin, 1893

During the latter part of World War II and into the early 1950s, my father and I spent time together in Jackson Park. Although my father was born nine years after the World's Columbian Exposition closed, he had an interest in the fair and the sites associated with it—an interest he shared and passed on to me. Our visits to Jackson Park usually included a stop at the Museum of Science and Industry, housed in the only surviving building from the fair, when it had been the Palace of Fine Arts. Daniel Chester French's smaller-scale *Statue of the Republic* (a replica of the original), the lagoons, Wooded Island, and a replica of the *Santa María* served as other reminders of the exposition. It is my father, Dr. Martin J. Di Cola, to whom I owe the beginning of my long-term interest in and research on the Columbian Exposition, so it is to his memory that I dedicate this work. And I also dedicate it to my grandsons Joseph, Christian, and Maximus in the hope that they will develop an avid interest in history.

—Joseph M. Di Cola

As a Chicagoan, I've been surrounded by the city's architecture my entire life but didn't always realize what it meant, where it came from, or its stature in the world. I just knew that I liked it. Now that I know more about it, and through the publication of my previous Arcadia book, *Chicago's Classical Architecture: The Legacy of the White City*, I'm more and more appreciative of architecture and history, not only in Chicago, but also everywhere I go. If I could go back in time, the White City might be my first stop. Thanks to Joe and Arcadia for inviting me take this trip with them.

—David Stone

This work could not have been completed without the resources available from previous works on the exposition. These works are listed in the Bibliography on page 127.

Also, many thanks are due to the following archives that generously gave permission for use of the images in this work: the Illinois Institute of Technology, Paul V. Galvin Library (particularly Paul Go); the Library of Congress; Brian Karpuk of Newsburglar.com; Jason C. Libby and the Poland Spring Preservation Society; Lorraine Straw and the Friends of the Viking Ship; and Dick Lieber of u505.com. David Stone photographed some of the images of the fair sites as they appear today. Finally, we wish to extend our thanks to Melissa Basilone, former senior acquisitions editor at Arcadia Publishing, whose own interest in the World's Columbian Exposition provided both the impetus and initial encouragement for this project, and to Jeff Ruetsche, publisher at Arcadia, who advised on the project through its completion and provided invaluable assistance with images.

INTRODUCTION

What came to be known as the World's Columbian Exposition was planned to commemorate the 400th anniversary of Christopher Columbus's 1492 landfall in the New World on the Bahamian island the indigenous Taino called Guanahani. At the end of the 1880s, four cities expressed interest in hosting the exposition: Chicago, New York City, St. Louis, and Washington, DC. The final decision on the site was left up to the US Congress. By 1890, it was clear that only two of the sites had the financial resources to plan for, build, and maintain the fair—Chicago and New York City. New York financiers initially pledged $15 million toward a fair; however, the fair was awarded to Chicago because, in addition to contributions from leading financiers, other financial support was pledged from the City of Chicago, State of Illinois, and subscriptions from ordinary citizens. This was a coup for Chicago, coming as it did a little over two decades after the devastating 1871 fire that had destroyed so much of the city. According to one story, Chicago's boasting of its greatness in trying to convince others that it should host the fair prompted a New York reporter to refer to the "hot air" boasting of Chicago as "that Windy City."

The site finally selected for the fair was Jackson Park, originally designed by Frederick Law Olmsted and Calvert Vaux in 1871. The proposed site was a marshy area covered with dense, wild vegetation. Much of the planning for the fair's location was done by Olmsted, the premier landscape artist in the country, who with Vaux had previously designed New York City's Central Park. As part of the plan, he envisioned lagoons and other water features complete with an island. Daniel H. Burnham and John W. Root were selected as chief architects; other well-known architects designed many of the fair buildings, most notably, McKim, Mead & White; Richard M. Hunt; Charles B. Atwood; Henry Ives Cobb; Louis Sullivan; Dankmar Adler; William Le Baron Jenney (credited with building the first "skyscraper," the Home Insurance Co. Building in Chicago); and Solon S. Beman. Included in the group of planners were sculptors and other artists. In addition to the Great Buildings, these and other architects also designed dozens of other fair buildings.

The fair featured several different thematic areas: the Great Buildings; Foreign Buildings; State Buildings; and a nearly mile-long area, the Midway Plaisance, that featured exotic exhibits; the first Ferris Wheel; and other entertainments. The area covered by the fair and the midway was 633 acres.

The buildings consisted of either iron or wood frames covered with staff, a compound of cement, plaster, and jute. These materials were used because of the lack of time to construct permanent buildings. It was determined that this exterior coating would be covered with white paint (hence the nickname "White City" for the structures sited near the Grand Basin). The architectural style of the fair's main buildings was Beaux-Arts, a decorative style of Neoclassical design, of which architect Louis Sullivan quipped, "Damage wrought by the World's Fair will last for half a century from its date, if not longer," due to his dismissal of the style's invocation of the past and other cultures, rather than the use of a more modern and indigenous style. There was already a burgeoning Chicago School of Architecture that was at variance with the look of the fair.

The World's Columbian Exposition opened on May 1, 1893. Pres. Grover Cleveland was on hand for this event and, after a speech, pressed the button that turned on the lights and machinery. These were uncertain times that experienced one of the worst economic downturns in American history up to that point; therefore, prices for transportation, admission, rides, restaurants, souvenirs, and other attractions were an important consideration. Transportation to the exposition was by surface lines, trains, or steamships and ranged in cost from 20¢ to 25¢. Admission prices were 50¢ for adults, 25¢ for children under 12 years of age, and free for children under six.

The Chicago World's Fair featured some famous firsts presented to a national audience: Aunt Jemima pancake mix, Cracker Jack, Cream of Wheat, the Ferris Wheel, Pabst Beer (it won the blue ribbon prize and thereafter became known as Pabst Blue Ribbon beer), Quaker Oats, Shredded Wheat, US commemorative stamps and coins, Anton Dvorak's *New World Symphony* in honor of the exposition (however, it was never performed at the fair), the term *midway* for the amusement area at a fair, ragtime music (introduced by Scott Joplin), motion pictures (Thomas Edison's kinetoscope and Eadweard Muybridge's zoopraxiscope), the use of the Nikola Tesla/ George Westinghouse polyphase alternating current system to power the fair and its illuminations, women as major exhibitors at a world's fair (with their own exhibition building), and the belly dance (courtesy of "Little Egypt" in the Street of Cairo exhibit on the midway). It is also said that L. Frank Baum drew his inspiration from the White City for his Emerald City in *The Wonderful Wizard of Oz*.

The World's Columbian Exposition also offered many opportunities for education through almost 6,000 lectures arranged by the World's Congresses. These presentations offered a wide array of topics in the arts and sciences, moral and social issues such as temperance, economics, labor, and religion. Noteworthy presenters included Woodrow Wilson (then a college professor), William Jennings Bryan, John Dewey, Hamlin Garland, and Frederick Jackson Turner, whose speech on "The Significance of the Frontier in American History" became a landmark idea in American historiography.

In spite of the Panic of 1893 that brought one of the worst depressions in American history, 28 million visitors attended the fair. The fair generated nearly $33 million in receipts against $30.5 million in expenses and a return of 10 percent to the fair's stockholders.

After the fair, the Ferris Wheel was first moved to the Lincoln Park area in 1895 and then to the 1904 World's Fair in St. Louis. On May 11, 1906, the Ferris Wheel was destroyed and sold for scrap. Remaining in Jackson Park in 1896 were the Palace of Fine Arts, the La Rabida monastery, the German Building, the three Columbus replica ships (the *Santa María*, *Pinta*, and *Niña*), the Iowa Building, the Viking Ship, and the Ho-o-den in the Japanese Garden on the Wooded Island. A few buildings ended up in other states. The *Pinta* sank in 1918, the *Nina* burned in 1919, the German Building and Ho-o-den were destroyed by fires in 1925 and 1945, respectively, and the Iowa Building was razed in 1936. La Rabida first became a fresh air sanitarium for sick children and later burned down but was replaced by a new La Rabida Hospital, and the *Santa María* was destroyed in 1952. The Viking Ship, after a trip to New Orleans, returned to Chicago and was placed outside of the Field Columbian Museum (formerly the Palace of Fine Arts at the fair and later the Museum of Science and Industry) until it was restored and moved to Lincoln Park in 1920. In 1996, after years of neglect and exposure to weather, the vessel was placed under a canopy in Good Templar Park in Geneva, Illinois, where she is undergoing restoration and preservation. The carved stem and stern post of the vessel are now in storage at the Museum of Science and Industry. In 2007, the Viking Ship was declared one of 10 most endangered historic sites in Illinois.

On the former site of the fair's Administration Building is a smaller-scale replica of the *Statue of the Republic* (the original, 65 feet tall, was destroyed in 1896, and the replica is 24 feet). The only extant building is the former Palace of Fine Arts, now the Museum of Science and Industry, which originally had been constructed of brick and plastered with staff. In the 1930s, the exterior was rebuilt with stone.

What follows is an illustrated tour of the World's Columbian Exposition, from the development of the site, through the grounds and attractions, and ending with its destruction and a visit to what remains of the fair today.

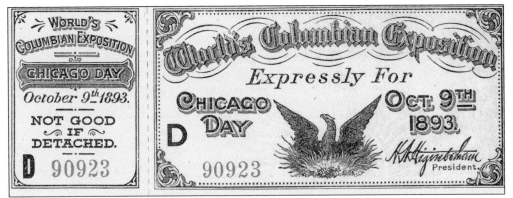

TICKET FOR CHICAGO DAY, OCTOBER 9, 1893. "Chicago Day" at the fair occurred on October 9, 1893, and was attended by more than 750,000 people. However, a pall was cast over that event because, three days before, Chicago mayor Carter Harrison had been assassinated. The final day of the World's Columbian Exposition, which had been open for six months, was October 30, 1893. Although fires on January 8, the last week in February, and July 5, 1894, had destroyed many of the exposition's structures, by October 1896, a salvage company had removed all but a few reminders of the fair. (Di Cola collection.)

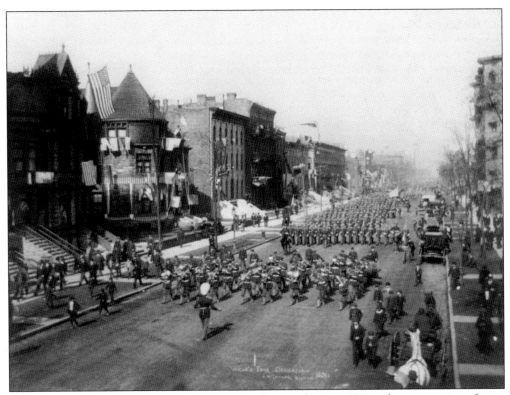

FAIR DEDICATION, MICHIGAN AVENUE PARADE. On October 21, 1892, with construction of most major buildings far from complete and several months before the fair would be open to the public, this ceremony marked the official arrival of the World's Columbian Exposition to Chicago. (Library of Congress.)

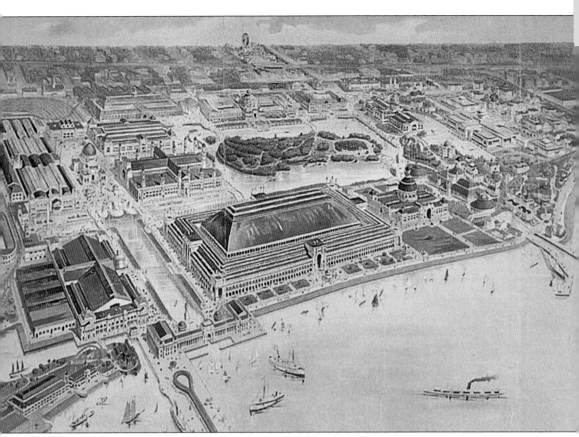

AERIAL VIEW OF THE FAIR. Popular images of the fair included color lithographs which gave a bird's eye view of the fairgrounds. These depictions usually contained a key to the buildings and other sites. Since some of these were produced while the fair was still under construction, they are often conjectural. (Library of Congress.)

One

THE DEVELOPMENT

OF THE SITE

Jackson Park was originally designed by Frederick Law Olmsted and Calvert Vaux in 1871, but nothing came of the plans. Although some development had occurred in the northern part of the park, the proposed site for the fair was an uninviting marshy area covered with sand and dense, wild vegetation. The exposition's planners, Olmsted and his then partner Henry Codman, envisioned waterways, undulating landscapes, a "wooded island," and beautiful gardens. In addition to buildings for exhibits and other purposes, there would be structures for foreign countries and US states, fountains, statuary, and a midway for other entertainments. In January 1891, work began.

Because of the marshy nature of the soil, the buildings rested on timber piles driven deep into the ground. The structures were constructed with iron or wood frames, and exterior walls were typically made from lath covered with staff, a compound of cement, plaster, and jute. This compound was as durable as wood and could be processed with carpentry tools. The staff coating was covered with white paint.

When the construction was complete, there were 14 Great Buildings, with a combined area of 63 million square feet, and 200 other buildings. The Grand Basin, lagoons, and other waterways covered over 60 acres. The fair was illuminated at night, requiring several thousand arc lights and well over 100,000 light bulbs.

The fair promoters wanted an attraction that would be more wondrous than the Eiffel Tower from the Paris Exposition Universelle in 1889. George Washington Gale Ferris Jr., who was employed by a company that built bridges, approached the Columbian Exposition's Ways and Means Committee with plans for a giant wheel that people could ride but he was thought to be insane. Ferris was not to be put off and was finally granted permission to build the wheel, not on the main fairgrounds but on the midway.

When completed, the 264-foot-tall wheel on a 71-ton axle had 36 cars (each 24 feet long, 13 feet wide, and 10 feet high) that could each carry 60 people. To speed up loading and unloading of passengers, there were six boarding areas. Although the fair had opened on May 1, the Ferris Wheel opened to fairgoers on June 21.

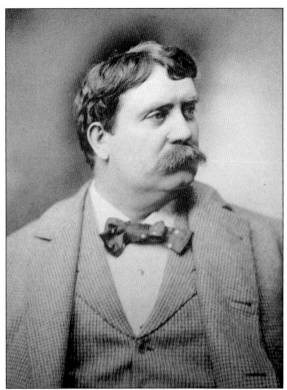

DANIEL H. BURNHAM. Burnham (1846–1912) was an American architect and urban planner who, with his partner John W. Root (1850–1891), was commissioned to design the buildings at the World's Columbian Exposition. The architectural designs of Burnham and Root resulted in modern-style buildings that became associated with the Chicago School style. After Root's unexpected death from pneumonia in 1891, Burnham joined with other landscape designers and architects and altered Root's plans for modern, colorful buildings for the fair, opting instead for a Beaux-Arts style. Daniel Burnham is also known for his 1909 Plan of Chicago. (Library of Congress.)

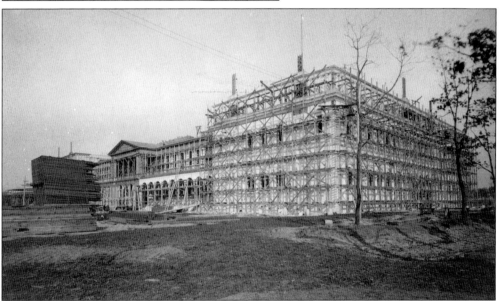

WOMAN'S BUILDING UNDER CONSTRUCTION. There was a Board of Lady Managers authorized for the World's Columbian Exhibition, and it resulted in the construction of the Woman's Building. Some features included a skylight, which filled the grand hall with light, loggias from which fairgoers had sweeping views, and cafés at each end of the roof. Once the structure was nearing completion, statues representing Sacrifice, Charity, Virtue, and Wisdom were added to the exterior. At each end of the interior were murals by Mary Cassatt and Mary Fairchild MacMonnies. (Library of Congress.)

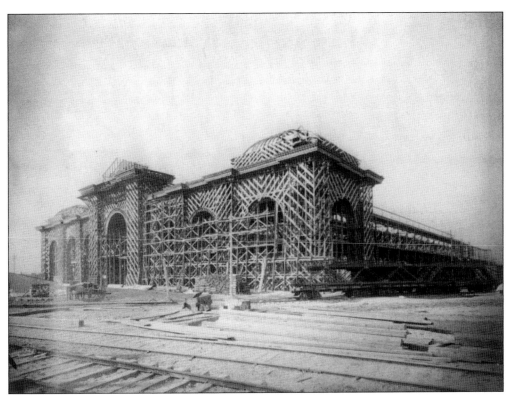

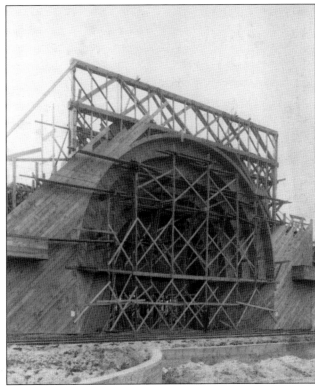

MINES AND MINING BUILDING UNDER CONSTRUCTION. This image shows a more complete view of the Mines and Mining Building's structure. The building would be described as both "massive" and "graceful," with its 140-foot central arch, domed pavilions, heavy pilasters, and elaborate and decorative frieze. (Library of Congress.)

GOLDEN DOORWAY OF TRANSPORTATION BUILDING UNDER CONSTRUCTION. Louis Sullivan's Transportation Building was the most significant departure from the generally classical motif of the Great Buildings, and its Golden Doorway was its most striking feature. Shown here is the beginning of what would become the entrance's receding arches that were ultimately covered in gold leaf. (Library of Congress.)

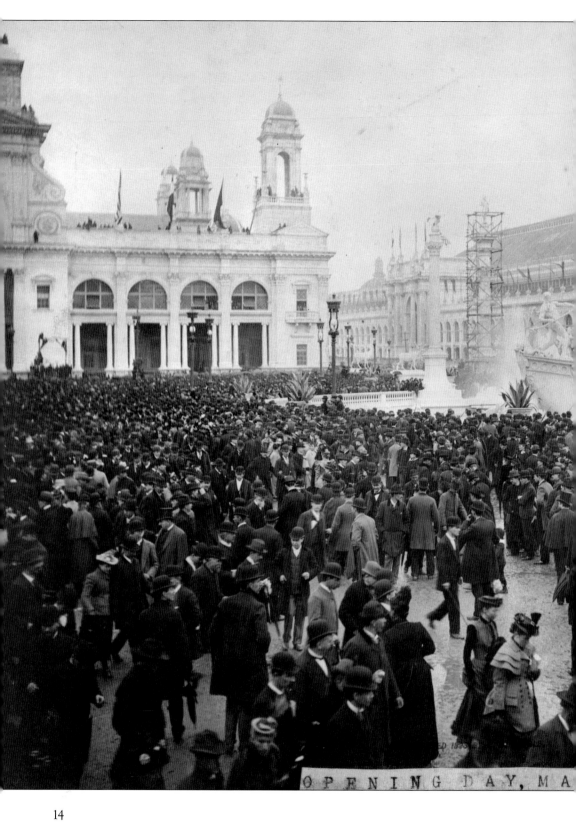

OPENING DAY, MA

14

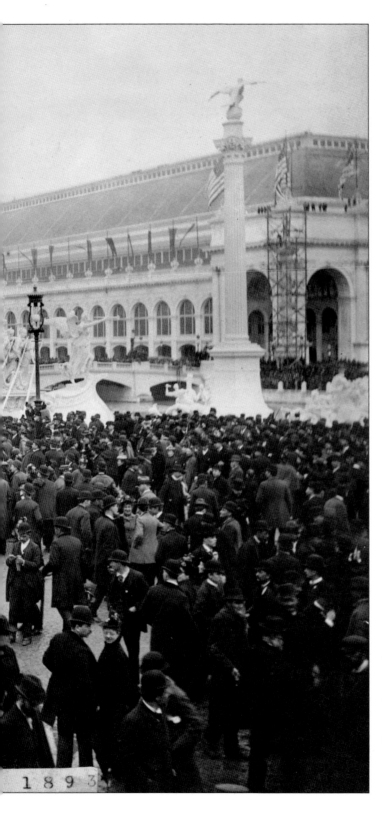

1893

OPENING DAY CROWDS.
Pictured are some of the
129,000 visitors from
Chicago and around
the world who attended
opening day, May 1, 1893.
The exposition had drawn
over 28 million visitors by
closing day, October 30,
1893. (Library of Congress.)

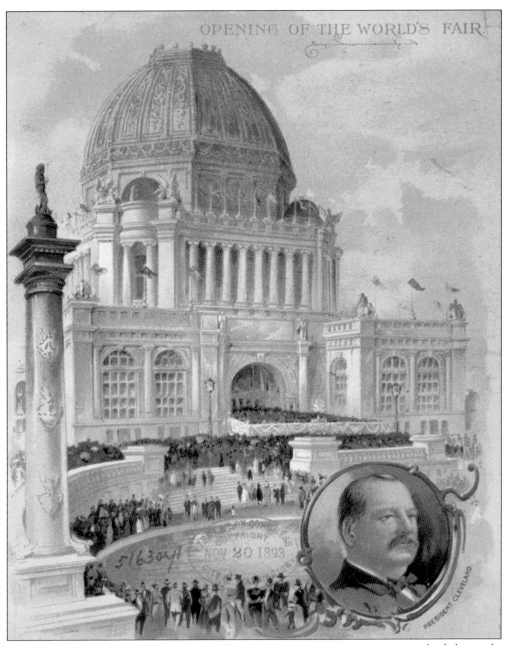

OPENING DAY COMMEMORATIVE POSTER. This 1893 commemorative poster is a color lithograph, produced by Knapp Company Lithographers of New York City, and depicts the Administration Building with an inset portrait of Grover Cleveland, who was president of the United States when the fair opened. (Library of Congress.)

Two

THE GREAT BUILDINGS

There were 14 Great Buildings that displayed the latest wonders in manufacturing, agriculture, transportation, the arts, and other areas. Twelve architectural firms, including one headed by a woman, were involved in the design and execution of the buildings, and construction costs for each ranged from under $100,000 to $1.7 million (or more than $40 million in today's dollars). The size of these structures ranged in square footage from the Administration Building at 55,000 to the Manufactures and Liberal Arts Building at 1,327,669. All the Great Buildings, with the exception of Adler and Sullivan's Transportation Building, were generally in the Beaux-Arts style but incorporated elements of Classical, Renaissance, Romanesque, and other styles. The interiors of the buildings, with few exceptions, were "unfinished" halls or sheds for exhibitions of technology, products, and other displays that were the focal points for fairgoers, and therefore the finished look of the exteriors was not required.

The Manufactures and Liberal Arts, Electricity, Mines and Mining, and Agricultural Buildings, as well as Machinery Hall, were arrayed along the Grand Basin, Court of Honor, and the Administration Building. The Transportation, Horticultural, Woman's, Fisheries, and US Government Buildings faced the lagoon, as did half of the largest exhibition building, Manufactures and Liberal Arts. The Anthropology and Forestry Buildings were located at the southeast corner of the fair near the South Pond and the lakeshore. The Palace of Fine Arts was at the northern end of the fairgrounds, and its south porch faced the North Pond.

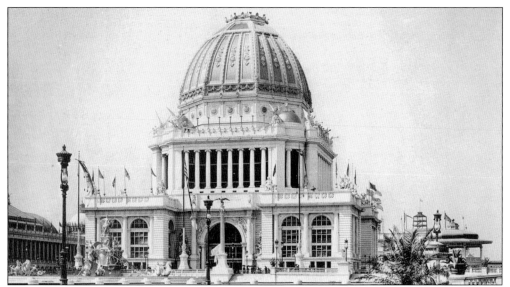

ADMINISTRATION BUILDING. Located at the end of the Court of Honor and fronted by a lagoon, this Beaux-Arts–style building, which served as headquarters for the officers of the exposition, was designed by Richard Morris Hunt of New York, who earlier had been the architect for the pedestal of the Statue of Liberty as well as the Marshall Field and William Borden houses in Chicago. The 55,000-square-foot structure, which dominated the Court of Honor, was capped by an impressive dome, 275 feet high and 120 feet in diameter. (*Official Views of the World's Columbian Exposition Issued by the Department of Photography [Official Views of the World's Columbian Exposition]*.)

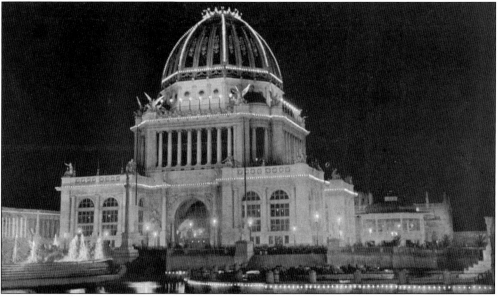

ADMINISTRATION BUILDING AT NIGHT. At night, the Grand Basin was ablaze with lights. The focal point of the illumination was the 275-foot-high octagonal dome of the Administration Building, lighted with incandescent bulbs that outlined its panels. The other Great Buildings surrounding the Grand Basin, the shoreline of the basin itself, and the MacMonnies and electric fountains were also illuminated by incandescent bulbs. (Paul V. Galvin Library, Illinois Institute of Technology.)

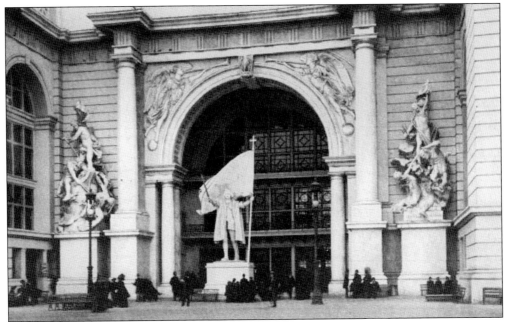

ADMINISTRATION BUILDING, EAST PORTICO, AND COLUMBIAN FOUNTAIN. Facing the Grand Basin, the Administration Building's east portico was one of the fairgrounds' most popular meeting spots. Its main feature was the central statue of *Columbus* landing in the New World; to his side were the *Water, Controlled* and *Water, Uncontrolled* statues that depicted man's mastery of the seas and Neptune destroying his victims, respectively. (Paul V. Galvin Library, Illinois Institute of Technology.)

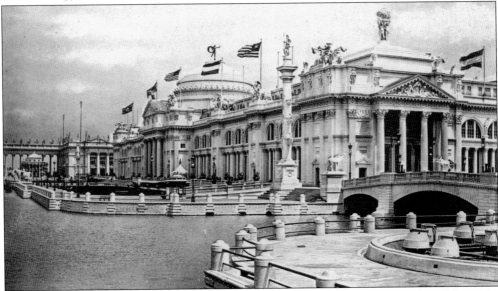

AGRICULTURAL BUILDING. Designed by the New York firm of McKim, Mead & White, the Agricultural Building housed a wide array of exhibits including models of farm structures; live animals like ostriches, farm products, machinery, and tools; and a "Liberty Bell" made entirely of oranges. A 22-ton cheese from Canada was another highlight. Both states and foreign nations were represented. (*Official Views of the World's Columbian Exposition.*)

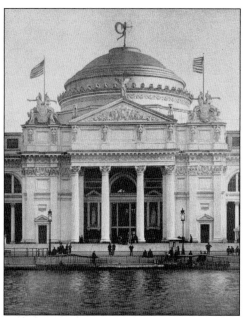

AGRICULTURAL BUILDING, ENTRANCE. Seen from across the Grand Basin is the Agricultural Building's north entrance and central dome. Topping the 130-foot-diameter dome was Augustus Saint-Gaudens's *Statute of Diana*, which was originally designed for New York's Madison Square Garden but proved to be too big for the arena. Around and above the porch were various figures from Greek mythology, such as *Ceres*, *Cybele*, and *King Triptolemus*. (Paul V. Galvin Library, Illinois Institute of Technology.)

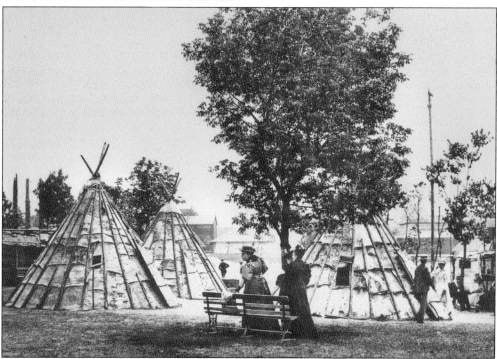

ANTHROPOLOGY BUILDING, PENOBSCOT INDIANS. Tucked away at the southeast corner of the fair along with the Forestry Building, the Atwood-designed Anthropology Building exhibited human history and artifacts from cultures in the Americas. Outside of the building were exhibits of actual native peoples who demonstrated everyday life in their respective cultures, for example, families of Penobscot Indians living in birch bark wigwams. Today, many of the anthropology exhibits are part of the collections in the Field Museum of Natural History. A number of other fair buildings also offered anthropology exhibits. (*Official Views of the World's Columbian Exposition.*)

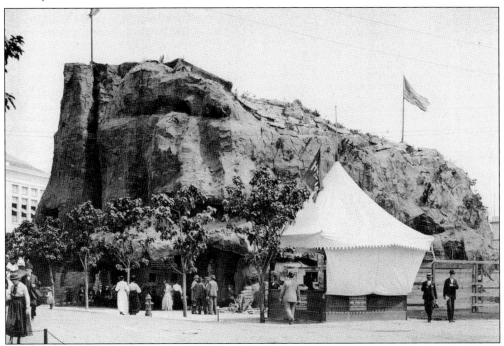

THE CLIFF DWELLERS. Another exhibit near the Anthropology Building featured the cliff-dwelling Indians of the Southwest. The structure made of timbers, rocks, and painted staff recreated Battle Rock Mountain in Colorado. The entrance was designed as a canyon where, in areas high up, visitors saw one-sixth scale replicas of the dwellings occupied by ancient peoples living on the mesas in the Southwest. Fairgoers were able to climb to the top of the exhibit. There was an area set aside as a museum of relics, including weapons, pottery, and actual portions of ancient cliff dwellings. (*Official Views of the World's Columbian Exposition*.)

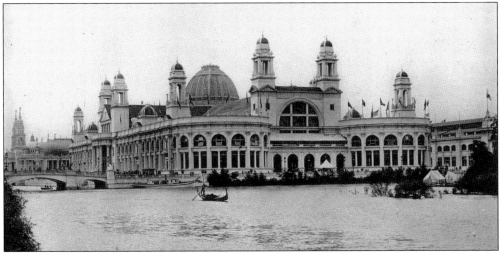

ELECTRICITY BUILDING. The Electricity Building, designed by Van Brunt & Howe of Kansas City, was a very popular exhibition. A statue of Benjamin Franklin stood at the entrance to the building. Electricity, and its place in American life, was still a novelty to many. Outside of this building, the visitors also experienced the electricity-powered Moveable Sidewalk and launches used on the waterways. (*Official Views of the World's Columbian Exposition*.)

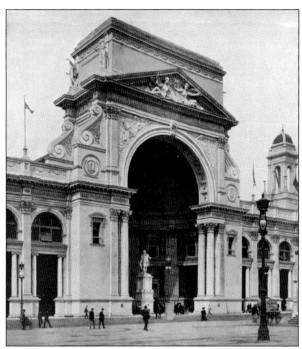

ELECTRICITY BUILDING, STATUE OF BENJAMIN FRANKLIN AT ENTRANCE. The latest wonders of electricity presented to the fairgoers included the outside illuminations and interior lighting of the buildings, Edison's kinetoscope (where one could view motion pictures), search lights, the chicken egg incubator, the first seismograph, and Morse's first telegraph message, "What hath God wrought!" (Paul V. Galvin Library, Illinois Institute of Technology.)

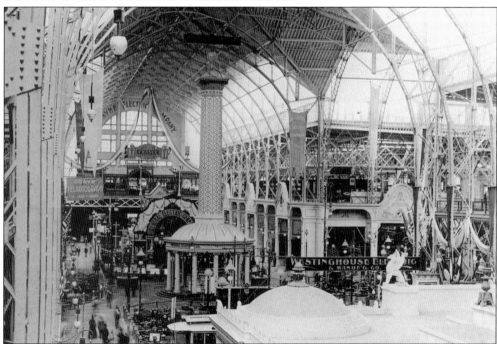

ELECTRICITY BUILDING, EDISON'S TOWER OF LIGHT. The Edison-designed tower of light consisted of over 18,000 light bulbs. It was over 80 feet tall. Thomas Edison lost the bid to provide the electrical power for the machinery and illuminations to George Westinghouse. The fair was illuminated at night, requiring several thousand arc lights and an estimate of over 200,000 light bulbs powered by Nikola Tesla's polyphase alternating current system. (*Official Views of the World's Columbian Exposition.*)

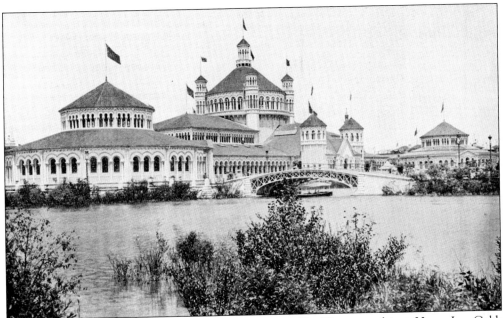

FISHERIES BUILDING. The Fisheries Building was designed by Chicago architect Henry Ives Cobb and was situated on the lagoon. It was a popular site because of the many aquaria displaying both freshwater and saltwater specimens. It was one of the few grand exhibition buildings that was not in the Beaux-Arts style, instead making use of glass for its walls. (Paul V. Galvin Library, Illinois Institute of Technology.)

FISHERIES BUILDING. There was a main building and two polygon-shaped buildings connected to the main structure by curved arcades. All of the detailed ornamentation was worked into various groupings of fish and other marine life. The sculpture in the large pediment over the main entrance facing south depicted scenes of whaling. In addition to the live exhibits, there were also displays of saltwater and freshwater fishing, the fish packing industry in the United State and other countries, and fish culture. (*Official Views of the World's Columbian Exposition.*)

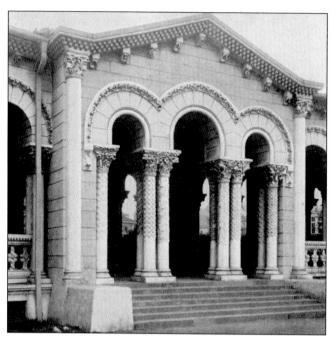

FISHERIES BUILDING, ARCADE. A close look at the Fisheries Building's arcade reveals intricate imagery related to marine life, such as frogs, serpents, tortoises, and reeds. The building's interior had a similar focus, and according to a guidebook, "everything that science has rescued from the depths of ocean, sea, lake or river, is displayed." (Paul V. Galvin Library, Illinois Institute of Technology.)

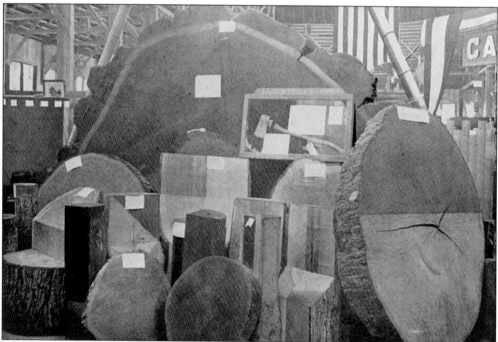

FORESTRY BUILDING, GLADSTONE'S AX. The Forestry Building, designed by Charles B. Atwood, was built of wood from trees donated by the states and foreign countries. Displays included species of trees, logging, petrified wood, and products made from wood. It was tucked away on the lakeshore at the southeast corner of the fair along with the Anthropology Building. One exhibit included cross-sections of tree trunks from several countries. The chief attraction, however, was an ax (in a glass case) used by former British prime minister William Gladstone on his estate. (Paul V. Galvin Library, Illinois Institute of Technology.)

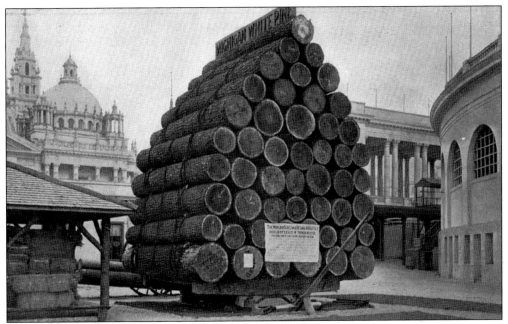

LOGGER'S CAMP, SAW LOGS. The dimensions of this stack of Michigan white pine were estimated at 36,000 feet of lumber weighing 140 tons. At the logger's camp, fairgoers saw a large log cabin used to house lumbermen, a representative assortment of lumbering tools, a sawmill, and many of the operations used in the logging and lumber industries. (Paul V. Galvin Library, Illinois Institute of Technology.)

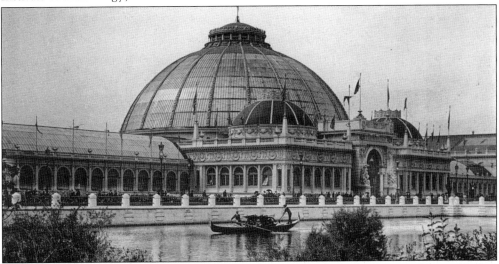

HORTICULTURAL BUILDING. Designed in the Renaissance style by the architectural firm of Jenney and Mundie, the glass domes and roof provided maximum natural light for the many plants inside of the structure. There were eight 2,400-square-foot greenhouses designed by Atwood, in addition to the nearly 250,000 square feet occupied by the main building. The interior featured several biomes and an artificial plant-covered mountain, and underneath was a crystal cave that visitors could explore for an extra fee. The building was surrounded by elaborate landscaping, and the staff also maintained most of the acreage on the Wooded Island. (*Official Views of the World's Columbian Exposition.*)

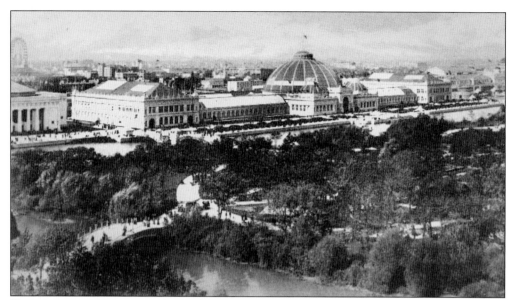

HORTICULTURAL BUILDING. This bird's-eye view of the Horticultural Building's site (of more than five acres) also includes the midway's Ferris Wheel at the left edge. The Venetian Renaissance building served mainly as a conservatory, with greenhouses, galleries, and exhibits of plants, flowers, grasses, fruits and vegetables, and wines from around the world—including a Classical-inspired 30-foot column made of California oranges. (Paul V. Galvin Library, Illinois Institute of Technology.)

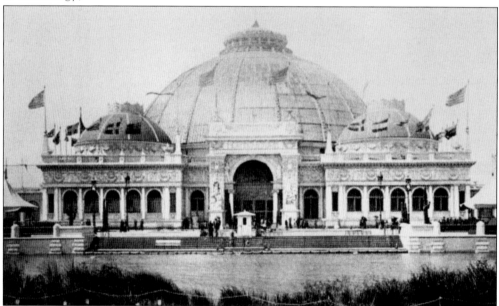

HORTICULTURAL BUILDING, THE DOME. The Horticulture Building's main dome was fronted by an ornate main entrance highlighted by a frieze of cherubs and vines. The dome itself was made of glass in order to provide light for the living exhibits inside. Outside the building, on the Wooded Island in the foreground, was the largest assortment of roses ever collected. The building was designed by Chicago architects Jenney and Mundie. (Paul V. Galvin Library, Illinois Institute of Technology.)

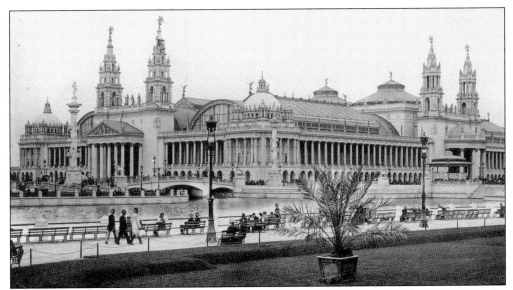

MACHINERY HALL. Machinery Hall and its annex, shops, and boiler house were designed by the firm Peabody & Stearns of Boston. Inside the exhibits included the giant Allis-Corliss engine, whose belts transmitted power to the dynamos that provided electrical power to the exposition. In addition to the Allis-Corliss engine, the building exhibited the impressive Galloways engine, Eli Whitney's cotton gin, the fair's power plant, varieties of sewing machines suited to specific tasks, and a great number of powered tools. The 842-foot-long building also had a traveling overhead crane used for moving the heavy machinery. (*Official Views of the World's Columbian Exposition.*)

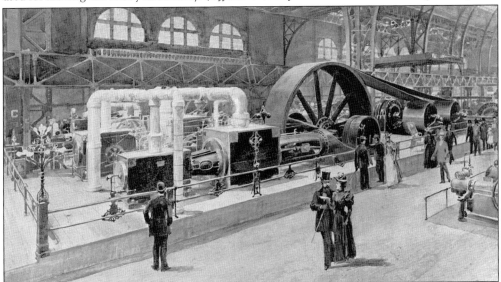

MACHINERY HALL, ALLIS-CORLISS ENGINE. The largest of its kind in existence at the time, the Allis-Corliss engine was from the Allis Company of Milwaukee. It generated 2,000 horsepower, covered 3,000 square feet of exhibition space, had a flywheel 30 feet in diameter, and featured a cylinder that was six feet in diameter. The engine powered two dynamos that could provide electricity to 20,000 light bulbs. When Pres. Grover Cleveland pressed the button to activate the fair's machinery on opening day, the Allis-Corliss engine was the device that set everything into motion. (Paul V. Galvin Library, Illinois Institute of Technology.)

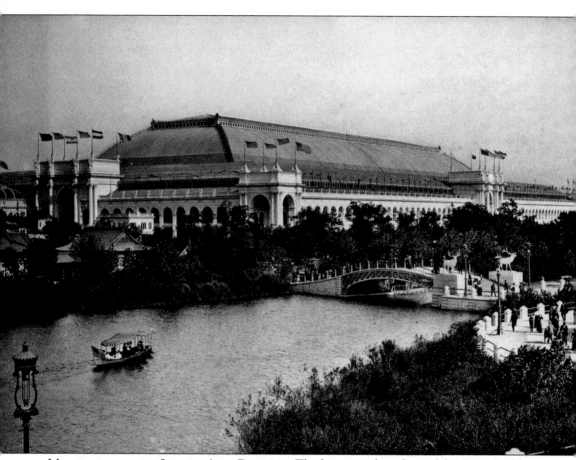

MANUFACTURES AND LIBERAL ARTS BUILDING. The largest and costliest of the Great Buildings at a 1.3 million square feet and $1.7 million, George B. Post's Manufactures and Liberal Arts Building exhibited both manufactured goods and those that covered the liberal arts of literature, history, science, graphic and functional arts, and music from all parts of the world. One of the chief exhibits was the 40-inch Yerkes refracting telescope from the University of Chicago's Yerkes Observatory, now at Williams Bay, Wisconsin. Thirty-two thousand tons of structural materials were used in this building's construction. (*Official Views of the World's Columbian Exposition.*)

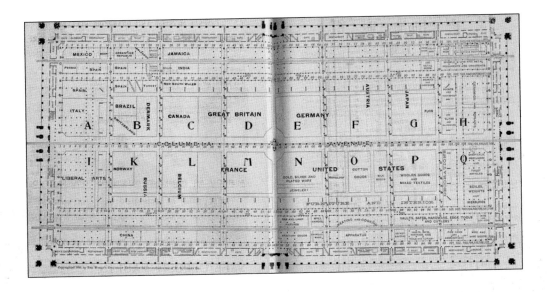

MANUFACTURERS AND LIBERAL ARTS BUILDING, FLOOR PLAN. Manufactures occupied almost the entire ground floor of this largest of the Great Buildings; the Liberal Arts displays were located chiefly in the southeast corner of the building. Great Britain, Germany, France, and the United States had the largest nation exhibits in the center area of the first floor, and these were flanked by smaller displays from Brazil, Canada, Austria, Japan, Norway, Russia, and Belgium. Other nation displayed their manufactures in the northeast corner. The gallery level featured manufactures and education exhibits. (Both, Paul V. Galvin Library, Illinois Institute of Technology.)

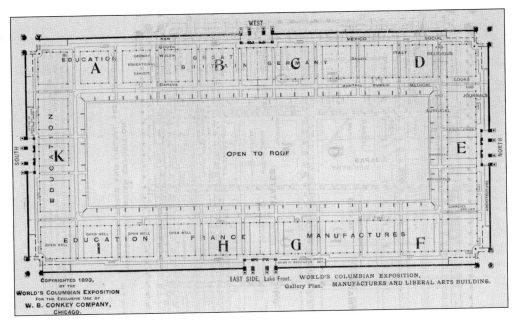

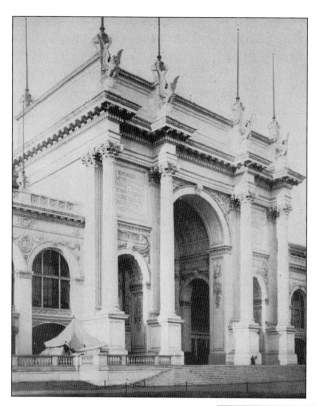

MANUFACTURES AND LIBERAL ARTS BUILDING, ENTRANCE. The massive size of the Manufactures and Liberal Arts Building dictated equally large entrances, and this was one of four that highlighted each side of the building. The entrances were modeled after Roman and Parisian triumphal arches, and their columns reached high above the 60-foot lower cornice. Even the decorative detail of the entrance was massively scaled—the eagles above the columns were 18 feet high. (Paul V. Galvin Library, Illinois Institute of Technology.)

MANUFACTURES AND LIBERAL ARTS BUILDING, YERKES TELESCOPE. Charles Yerkes donated $500,000 to the University of Chicago for the construction of the largest telescope in the world. There were two axles on which the telescope could be rotated in order to point in multiple directions. When the fair closed, the telescope was dismantled but remained in the Manufacturing and Liberal Arts Building and needed to be rescued on January 8, 1894, when the building was on fire. Subsequently, the telescope was installed in an observatory on the shore of Williams Bay, part of Lake Geneva, Wisconsin. (Paul V. Galvin Library, Illinois Institute of Technology.)

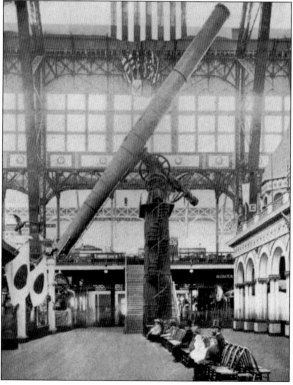

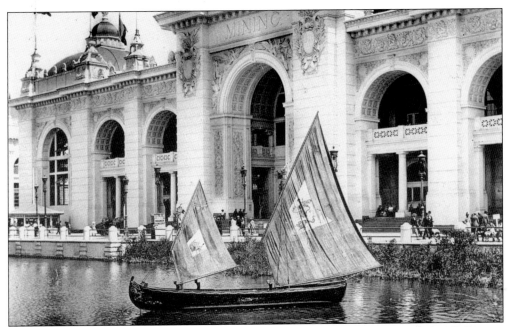

MINES AND MINING BUILDING. In a first of its kind at a world's exposition, Solon S. Beman of Chicago, famous for the town of Pullman, designed the Mines and Mining Building in the Beaux-Arts style. Two states, Colorado and Montana, exhibited statues made of silver, and Iowa displayed a small-scale model of a coal mine. Other displays included various ores and minerals and an exhibit on diamond mining by the Kimberley Company. (*Official Views of the World's Columbian Exposition.*)

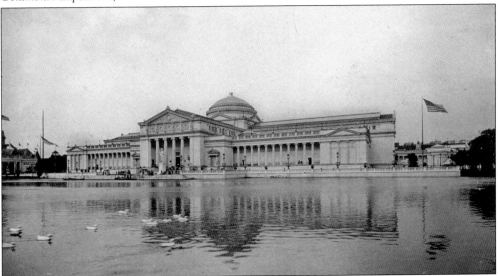

PALACE OF FINE ARTS. The 140 rooms in Charles Atwood's Fine Arts Palace displayed paintings and sculpture from the United States and Europe, including the works of some of the world's greatest artists. In addition to works from the United States and Europe, Japanese art was also exhibited. The galleries also displayed architectural copies of cathedral features from abroad. It is the only surviving building from the exposition in its original location and is now the Museum of Science and Industry. (*Official Views of the World's Columbian Exposition.*)

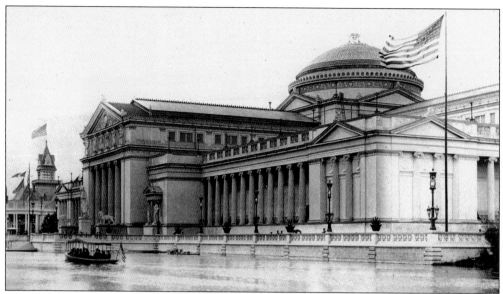

PALACE OF FINE ARTS, SOUTH PORCH. Sited on the north end of the lagoon, the south porch of the Palace of Fine Arts was the favorite of the four entrances to the building. Visitors arrived by boat and climbed a broad staircase to the entrance. One of the distinguishing architectural features of the building that can be seen in this image and in the structure today are caryatids, columns in the shape of female figures. (*Official Views of the World's Columbian Exposition.*)

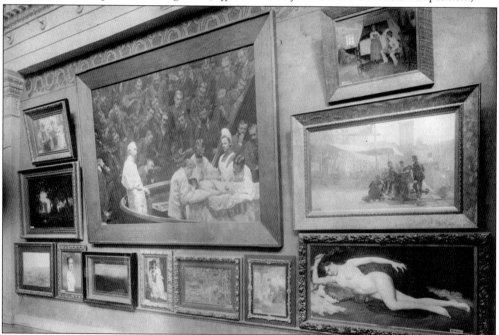

PALACE OF FINE ARTS, GALLERY 57. Gallery 57 was located in the French section of the Palace of Fine Arts. The artists whose works are displayed in this gallery include Ernest Bordes, Emile Dardois, Madeline Lemaire, Prosper Galerne, Eugene Delacroix, Paul Grolleron, and Albert Fourie. All of these painters were from Paris. Other works of art were displayed on pedestals, tables, and in glass cases. (Library of Congress.)

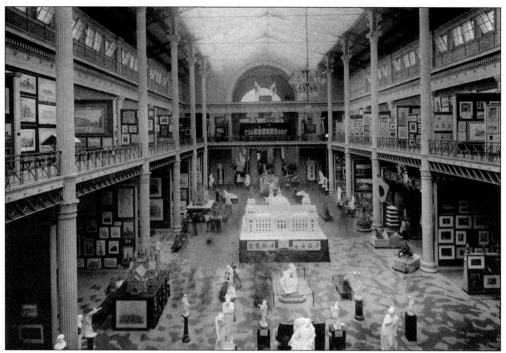

PALACE OF FINE ARTS, STATUARY. This display of sculpture was located in the north court of the Palace of Fine Arts. Some of the works are originals, and others are plaster casts of both public and museum works in Paris. Displayed in the galleries above the main floor are paintings by French artists. (*Official Views of the World's Columbian Exposition.*)

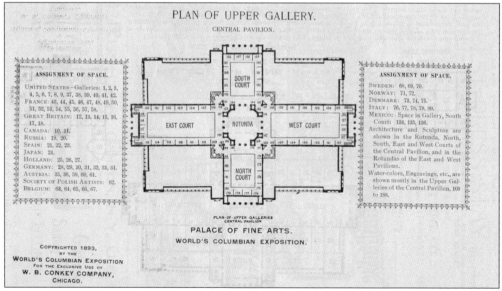

PALACE OF FINE ARTS, UPPER GALLERY PLAN. The visual arts of many countries were displayed in the central pavilion of the Palace of Fine Arts. Architecture and sculptures were exhibited in the rotunda and courts; paintings were hung along the walls and on freestanding display panels. On the upper galleries, fairgoers viewed watercolors and engravings from different nations. (Paul V. Galvin Library, Illinois Institute of Technology.)

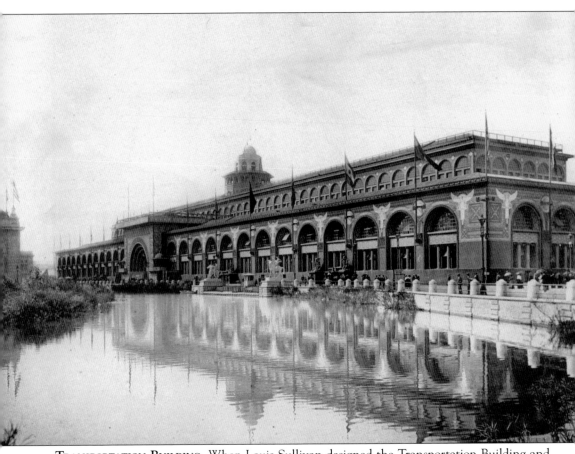

TRANSPORTATION BUILDING. When Louis Sullivan designed the Transportation Building and Annex, he did not follow the Beaux-Arts style of most of the Great Buildings because he felt that the latter did not represent the modern era of industry and scientific achievements. Rather than the stark white exteriors of the other buildings, Sullivan used a polychromatic scheme. Frank Lloyd Wright, a junior member of the Chicago architectural firm Adler and Sullivan, worked with Sullivan on the Golden Doorway. The relief work in its gilded arch represented transportation. (*Official Views of the World's Columbian Exposition.*)

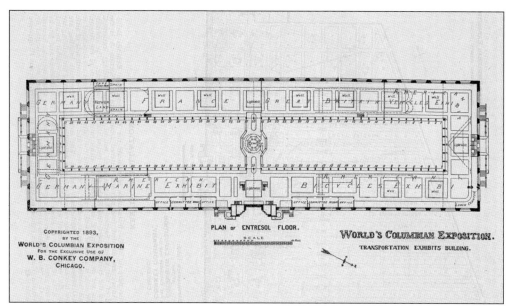

PLAN OF ENTRESOL FLOOR.
SCALE

WORLD'S COLUMBIAN EXPOSITION.
TRANSPORTATION EXHIBITS BUILDING.

TRANSPORTATION BUILDING, FLOOR PLANS. France, Germany, and Great Britain mounted large exhibits on the entresol or mezzanine floor of the Transportation Building. The remainder of the space was occupied by large exhibits of American marine modes of transportation and bicycles as well as of other American vehicles. The Netherlands and Spain had small displays on this level of the building. (Both, Paul V. Galvin Library, Illinois Institute of Technology.)

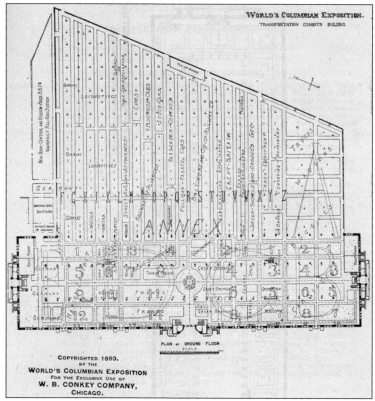

WORLD'S COLUMBIAN EXPOSITION.
TRANSPORTATION EXHIBITS BUILDING

PLAN OF GROUND FLOOR.
SCALE

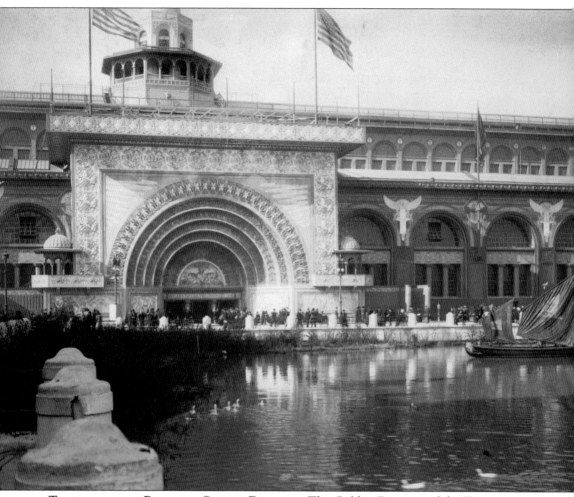

Transportation Building, Golden Doorway. The Golden Doorway of the Transportation Building consisted of a series of receding arches on the east front facing the lagoon. The rich detail included geometrical figures, bas-reliefs, arabesques, traceries, and foliation covered with several layers of gold leaf. Over the entrance doors is a beautiful allegorical tympanum. On either side of the Golden Doorway were a gallery, oratory, and organ stairs. Below these was a bas-relief depicting either ancient or modern transportation. The same rich details found in the receding arches of the Golden Doorway ornament the side features. The construction of the doorway was accomplished in a short time due to the use of staff for this intricate work. (Library of Congress.)

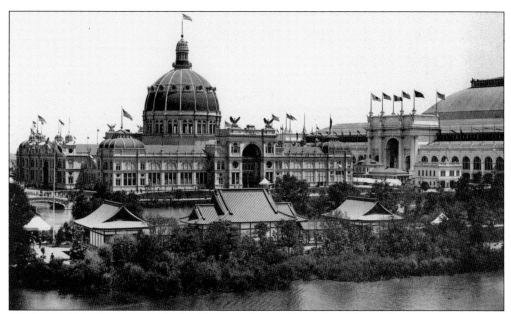

US Government Building. This building was designed by Willoughby J. Edbrooke of Washington, DC, and, in square feet, was one of the smaller spaces. It was a showcase for US history, displaying many historical documents, artifacts, patent models of inventions, and naval exhibits, and examples of every US postage stamp and currency since the nation's founding. The building also had displays that featured the various government departments. One of the major highlights was the trunk of a California redwood tree through which visitors could walk. (*Official Views of the World's Columbian Exposition.*)

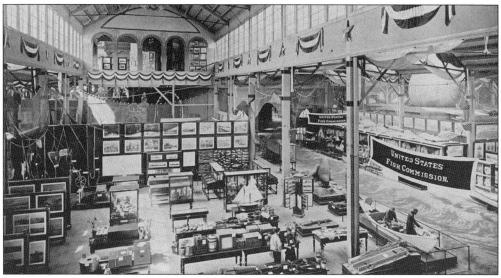

US Government Building, Interior Exhibits. The north part of the building featured exhibits from the Post Office Department and the Departments of Treasury, War, and Agriculture; the south part housed exhibits from the Smithsonian Institution and Department of the Interior. The State and Justice Departments exhibits ranged west and east from the central rotunda. There were many items from the colonial and revolution periods of the nation's history, coins, currency, and stamps. (Paul V. Galvin Library, Illinois Institute of Technology.)

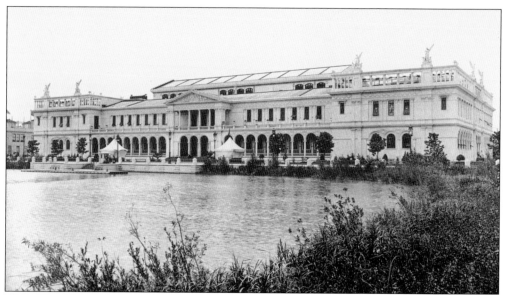

WOMAN'S BUILDING. Designed by Sophia Hayden of Boston, the Woman's Building was the largest exhibition building funded and devoted to exhibits of women's work up to that time. It was the headquarters of the Board of Lady Managers, chaired by Bertha Honore Palmer. The exhibits were largely educational, including a large library of works by women, and highlighted the progress of women over the ages in the arts and sciences. Inside were murals painted by noted female impressionist Mary Cassatt. Adjacent to the Woman's Building was the two-story Children's Building, designed by Alexander Sandier of Paris. (*Official Views of the World's Columbian Exposition.*)

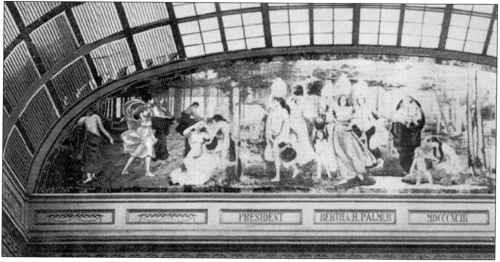

WOMAN'S BUILDING, TYMPANI, MARY CASSATT MURAL. Mary Cassatt was an artist whose talent was recognized by Mrs. Potter Palmer, president of the Board of Lady Managers, and by other board members. In the arched space over the north and south end of the galleries were the works of Mary Cassatt (*Modern Woman*) and Mary Fairchild MacMonnies (*Primitive Woman*). The latter was the first wife of Frederick MacMonnies who designed the Columbian Fountain for the fair. She was also an unknown artist whose talent was noted by the Board of Lady Managers. (Paul V. Galvin Library, Illinois Institute of Technology.)

Three

OTHER SIGNIFICANT BUILDINGS, SITES, AND EXHIBITS

In addition to the Great Buildings, there were a number of other structures and sites that were major attractions at the fair. Many of these were as architecturally striking such as the 14 Great Buildings and were designed by the some of the same architects, like Charles B. Atwood (Casino, Music Hall, Monastery of La Rabida, Peristyle, and Terminal Station), Solon S. Beman (Merchant Tailors Building), Henry Ives Cobb (Café de la Marine), and Peabody & Stearns (Colonnade and Obelisk). The replicas of Columbus's ships from the first voyage, fountains, the Viking Ship, bridges over the waterways, the Ho-o-den, and other sites on the Wooded Island also drew crowds of fairgoers.

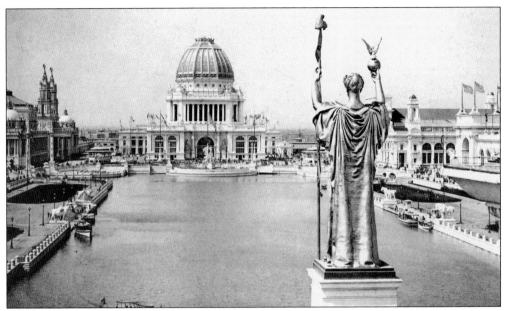

GRAND BASIN LOOKING WEST. This is a view of the Grand Basin looking west along the Court of Honor toward the Grand Plaza in front of the Administration Building. The MacMonnies Columbian Fountain and the Electric Fountains are at the end of the Grand Basin. Some of the Great Buildings are arrayed to the right and left in this photograph: the Agricultural Building, Machinery Hall, the Manufactures and Liberal Arts Building, and the Mines and Mining Building. (*Official Views of the World's Columbian Exposition.*)

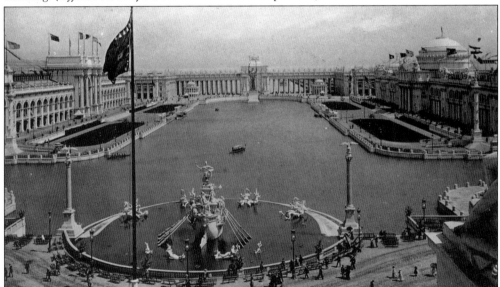

GRAND BASIN LOOKING EAST. One of the most spectacular sites is the Grand Basin, seen here facing east with the *The Republic* in front of the Peristyle Water Gate and Lake Michigan in the background. This water feature was a reflecting pool that was 1,300 feet long and 300 feet wide. In the foreground is Frederick MacMonnies's Columbian Fountain. At night, this entire area was illuminated with arc lighting playing on the Administration Building at the west end of the Grand Basin. (*Official Views of the World's Columbian Exposition.*)

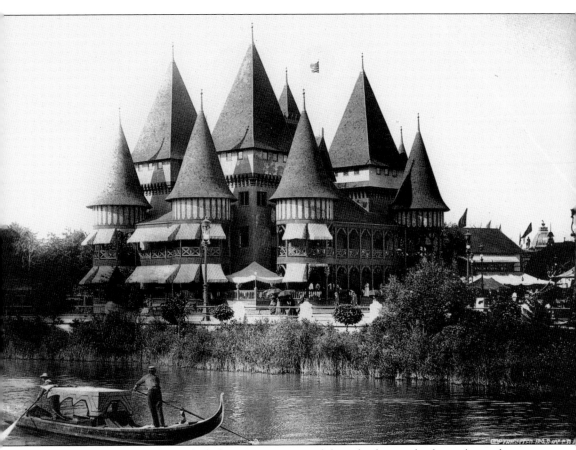

CAFÉ DE LA MARINE. The Café de la Marine, serving fish and other seafood, was located next to the Fisheries Building. It was designed by Chicago architect Henry Ives Cobb, who also designed the Fisheries. The exposition restaurants and stands offered the usual meat-and-potatoes American fare common to the era, including various food products made in the United States, but also tempted fairgoers with food and drink from Europe, North Africa, the Middle East, Asia, and Latin America, and with regional American specialties. (*Official Views of the World's Columbian Exposition.*)

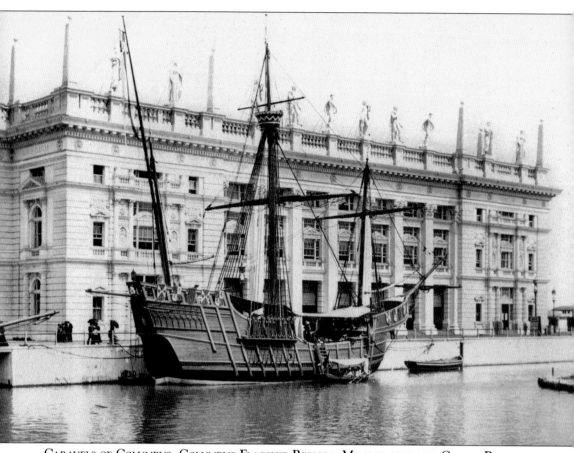

Caravels of Columbus, Columbus Flagship Replica, Moored next to Casino Building. One of the entrances to the exposition on Lake Michigan was at a dock next to which was the Casino, designed by Charles B. Atwood in the Renaissance style. It was perhaps the most elegant comfort station ever built, containing comfortable seating, smoking areas, and toilets. On the upper story, there was a large restaurant segregated by gender; although, there was also a café where couples could dine. For much of the run of the fair, the replica *Santa María* was moored alongside the Casino. Located at the north end of the Peristyle, the Atwood-designed Music Hall was identical to the Casino located on the south end of the former. The hall held 2,000 people who were treated to classical music performed by a 300-musician orchestra. On the occasion of the 400th anniversary of Columbus's first voyage, facsimiles of the three ships were built for the Chicago fair by a Spanish commission. The *Santa María* was launched on June 26, 1892, and was intended as a gift of Spain to be displayed at the World's Columbian Exposition. That same year, the US government placed orders for reconstructions of the *Pinta* and the *Niña*. *Santa María* was a *nao* (carrack); the *Pinta* and *Niña* were *carabelas* (caravels). The vessels arrived at Chicago July 7, 1893, over two months after the opening of the fair. (*Official Views of the World's Columbian Exposition*.)

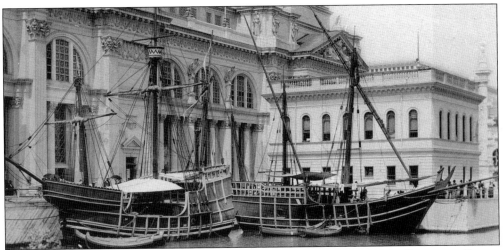

PINTA AND NIÑA REPLICAS, MOORED AT EAST END OF THE AGRICULTURAL BUILDING. Due to budget constraints, the hulls of two extant boats were used in the reconstructions, resulting in ungainly, disproportionate, and unseaworthy designs. Because of this, both ships had to be towed across the Atlantic instead of sailing on their own, while the *Santa María* sailed across the Atlantic. The facsimile of the *Niña* was rigged with lateen sails (unlike the original, which had been rerigged with square sails); the reconstructed *Pinta* was rigged incorrectly and was given a forecastle, something that is not believed to have been part of the original vessel. (*Official Views of the World's Columbian Exposition.*)

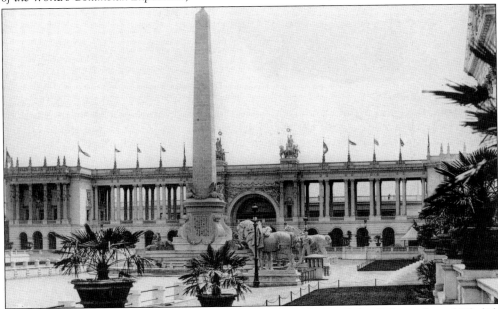

COLONNADE AND OBELISK. Located at the end of the South Canal the Colonnade and Obelisk were designed by the Boston firm of Peabody & Stearns. The Colonnade connected Machinery Hall and the Agricultural Building and also served as an entrance to the Stock Pavilion (Holabird & Roche) used for livestock exhibits. The Obelisk was 60 feet high and modeled after New York City's Cleopatra's Needle. On the top of the Colonnade were two sculptures, and to the left of those was mounted one of the powerful searchlights that provided some of the spectacular night illuminations. (*Official Views of the World's Columbian Exposition.*)

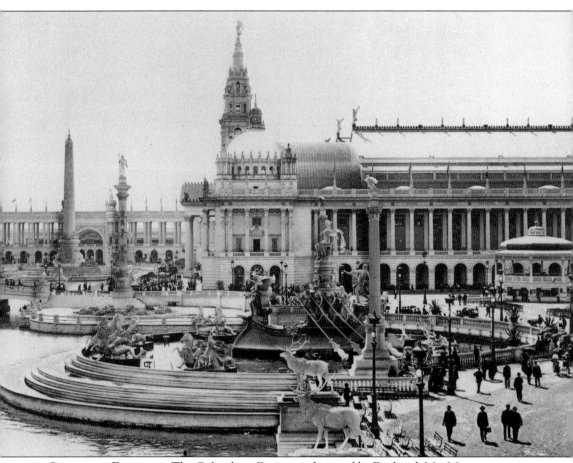

COLUMBIAN FOUNTAIN. The Columbian Fountain, designed by Frederick MacMonnies, is meant to symbolize the United States and is evocative of a ship. Its characteristic features include the figure of Columbia perched at the top, the head of an eagle for the prow, and eight rowers representing arts and industry, which are widely represented in the fair's 14 Great Buildings. Frederick MacMonnies was granted $50,000 to design and build the Columbian Fountain. It is an allegorical barge of state with Fame at the bow, Time at the rudder, pulled by horses representing Commerce, and rowed by Music, Architecture, Sculpture, Painting, Agriculture, Science, Industry, and Commerce. The barge, located in a 150-foot-wide pool, sent water cascading into the Grand Basin. Dolphins, mermaids, and tritons contributed to the flow of water. (*Official Views of the World's Columbian Exposition.*)

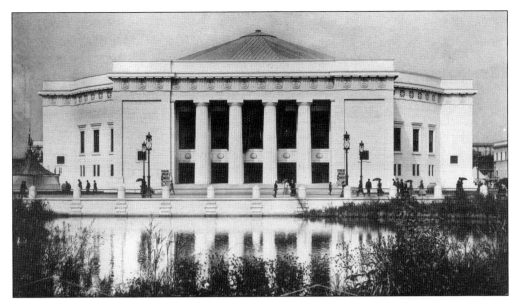

CHORAL BUILDING. Located near the lagoon between the Horticultural and Transportation Buildings and designed by Francis M. Whitehouse of Chicago, the Choral Building, also known as Festival Hall, contained an opulent theater that could seat 2,500 people who were treated to daily band and vocal concerts. The Classical-style exterior featured Doric columns and statutes of classical composers. (*Official Views of the World's Columbian Exposition.*)

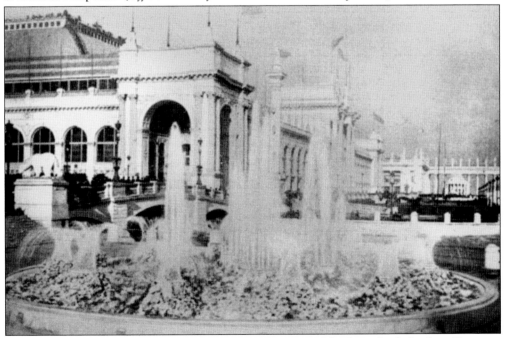

ELECTRIC FOUNTAINS. At the west end of the Grand Basin and flanking the Columbian Fountain were two Electric Fountains that were illuminated with colored lighting at night and could send jets of water over 100 feet high. When inactive, the fountains were made to look like many volcanic craters only to erupt at night into pyramidal and other shapes of green, gold, red, pink, yellow, blue, and multicolored "lava." (Paul V. Galvin Library, Illinois Institute of Technology.)

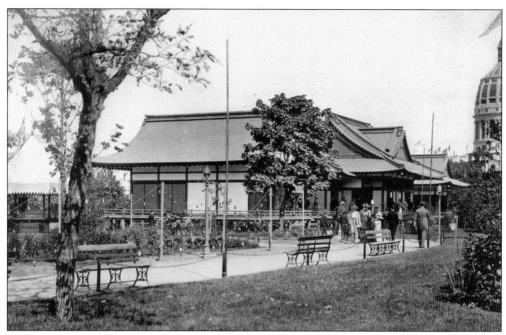

JAPANESE HO-O-DEN, WOODED ISLAND. Commissioned by the emperor of Japan, the Ho-o-den ("House like a Phoenix") was a copy of a temple near Kyoto. It was located toward the north end of the Olmsted-designed 16-acre Wooded Island. (*Official Views of the World's Columbian Exposition.*)

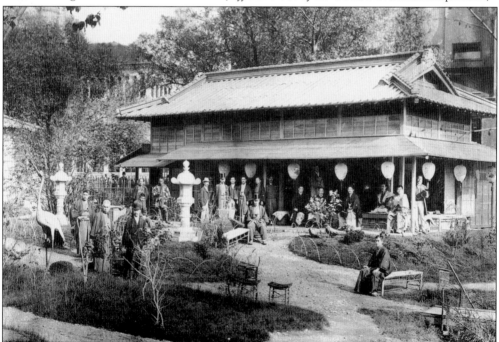

JAPANESE TEA GARDEN, WOODED ISLAND. The Wooded Island, sited in the lagoon, was planned to be a nature sanctuary and had trails, gardens, and benches designed for the relaxation of the fairgoers who wanted to temporarily escape from the crowds. (*Official Views of the World's Columbian Exposition.*)

KRUPP GUN EXHIBIT. This building displayed the world's largest piece of artillery (87 feet long with a range of 16 miles, weighing 124 tons, charged by a half ton of powder, and firing a one-ton projectile). To transport the world's largest artillery piece to Chicago required specially built railroad cars consisting of two pairs of double flatcars bridged together, which, in turn, were bridged by another span resting on eight railroad trucks. (*Official Views of the World's Columbian Exposition.*)

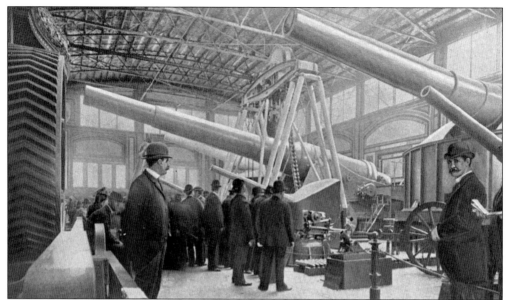

KRUPP GUN EXHIBIT, INTERIOR. The interior of the Krupp Building consisted of one large room. In addition to displaying the world's largest gun, the exhibit also showcased Krupp arsenal of weapons. The large gun was not fired during the fair, but steel targets that had been used for gunnery practice gave evidence of the destructive force of the weapon. The exhibit also highlighted steamship forgings crafted by the Krupp works in Germany. The entire Krupp exhibit cost $500,000. (Paul V. Galvin Library, Illinois Institute of Technology.)

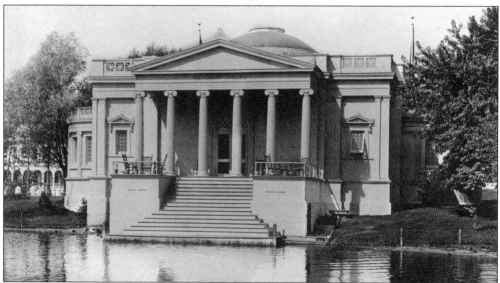

MERCHANT TAILORS BUILDING. Inspired by Classical architecture, this building was created by Solon S. Beman, who went on to build the first Christian Science church based on the same design, which was later used for many Christian Science churches. This structure served as a tribute to clothing. The interior of the building featured a central court with a mosaic floor surrounded by columns similar to those used for the portico. The walls were decorated with scenes on the development of human dress and other adornments over the centuries. (*Official Views of the World's Columbian Exposition.*)

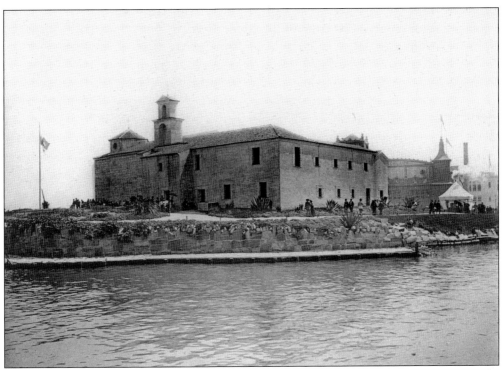

MONASTERY OF LA RABIDA. Designed by Charles B. Atwood, the replica of a monastery near Palos where Columbus first stopped in 1485 was a depository of Columbian relics, including letters and signatures of Columbus, photographs of places, and facsimiles of items associated with the admiral, even anchors from the *Santa María* and from a ship used on his third voyage. All of these were catalogued in a souvenir book, *The Relics of Columbus*. (*Official Views of the World's Columbian Exposition*.)

LA RABIDA SOUVENIR BOOK, COVER. Dispersed in 17 sections, there were 1,067 "relics of Columbus" displayed in the Monastery of La Rabida replica building. This souvenir book documents the items and is lavishly illustrated. These included both original and facsimile items, an example of the latter being the box in which the remains of Columbus were found in 1877 in Santo Domingo. The exhibit was the brainchild of William Eleroy Curtis, director of the Bureau of the American Republics at Washington and chief of the Latin American department of the exposition. (Di Cola collection.)

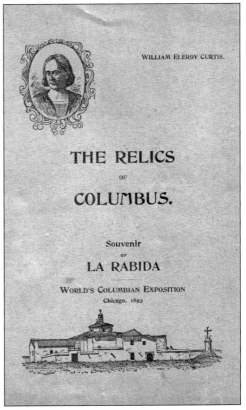

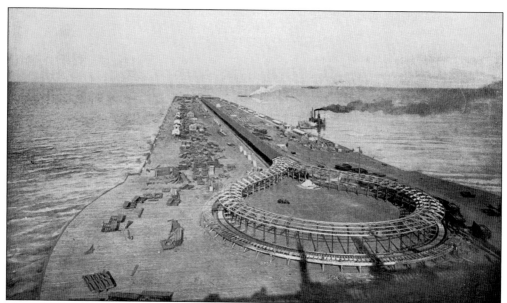

MOVEABLE SIDEWALK. The Moveable Sidewalk, shown above under construction, was located on the long pier east of the Peristyle and was constructed for the purpose of lessening the fatigue of visitors walking from the steamships, along the pier, into the fairgrounds. It extended 2,500 feet out into the lake. Owing to numerous delays in the construction, the sidewalk was not put into operation until July, but from which time until the close of the exposition, it carried 997,785 people. It was capable of carrying 6,000 people at a time at 5¢ per seat and moved at the rate of six miles an hour. Unfortunately, breakdowns were common for the Moveable Sidewalk. (Above, Paul V. Galvin Library, Illinois Institute of Technology; below, *Official Views of the World's Columbian Exposition*.)

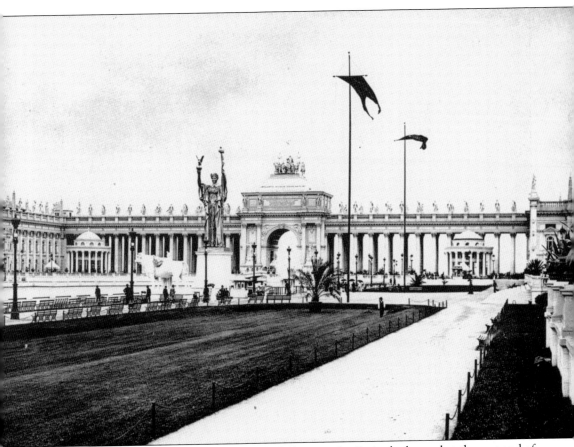

PERISTYLE. Designed by Charles B. Atwood of Chicago, the Peristyle, located at the east end of the Grand Basin, contained 48 Corinthian columns and connected the twin structures of the Casino (on the south) and Music Hall (on the north). On either side of the central opening are sculptures representing the "genius of navigation." Various heroic figures stand on the balustrade. Although the voyages of Columbus are celebrated at the fair, other explorers are also honored in the Peristyle. Its 48 columns represented the number of states and territories in 1893, the statues were of famous explorers, and the grouping at the top center, the Quadriga, was of Columbus in a chariot pulled by four horses. A breakwater protected the Peristyle from the waves in Lake Michigan. The combined cost of the Peristyle, Casino, and Music Hall was $200,000. (*Official Views of the World's Columbian Exposition.*)

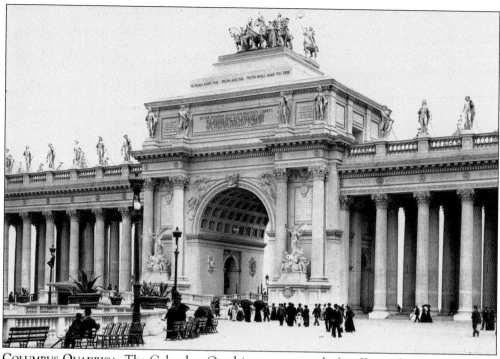

COLUMBUS QUADRIGA. The Columbus Quadriga, constructed of staff, was designed by Daniel Chester French and Edward Clark Potter who also designed the heroic horse and bull sculptures for the Grand Basin. The Quadriga group includes a chariot, four horses, three human figures, and two additional figures serving as couriers and holding victory standards. Two of the horses are pulling the chariot containing Columbus, led by two female figures leading two additional horses. The cost was $15,000. (*Official Views of the World's Columbian Exposition.*)

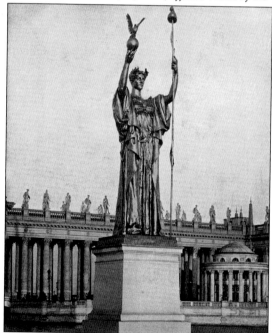

THE REPUBLIC. Noted sculptor Daniel Chester French designed the 65-foot-tall *The Republic*. It was made of plaster and covered in gold leaf. The base for the statue was 35 feet high, making this sculpture the largest at the exposition. In 1918, French made a 24-foot-tall gilded bronze model of *The Republic*, which still stands in Jackson Park on the site of the fair's Administration Building. French is best known for his seated *Abraham Lincoln* in the Lincoln Memorial. (Paul V. Galvin Library, Illinois Institute of Technology.)

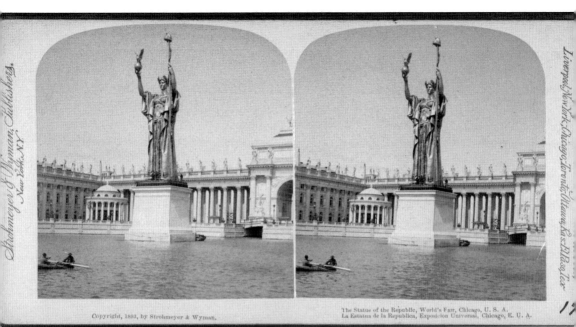

THE REPUBLIC. French's *The Republic* was the largest sculpture at the World's Columbian Exposition. Its position at the eastern end of the Grand Basin made it a centerpiece of the fair. After the close of the exposition, *The Republic* was spared the fiery destruction that happened to the Peristyle on the night of January 8, 1894, but eventually fell into disrepair and was a victim to a fire two years later. (Wikicommons.)

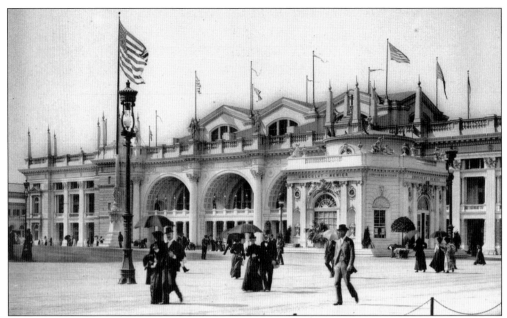

TERMINAL STATION. For those traveling to the exposition by train, this was the point of arrival at the fairgrounds. Designed by Charles B. Atwood, the station accommodated 35 tracks. Another option for reaching the fair was the South Side Rapid Transit, which extended its line from Thirty-ninth Street to Jackson Park for the convenience of travelers. The rapid transit station closed on October 30, the same day as the fair. (*Official Views of the World's Columbian Exposition.*)

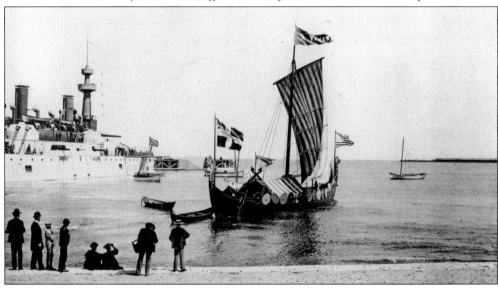

VIKING SHIP. In 1880, an ancient burial mound from the 9th century, containing a ship burial, was excavated at the Gokstad farm in Norway. This replica of the Gokstad ship was made in Norway and sailed across the Atlantic by Capt. Magnus Andersen and a crew of modern-day Norsemen, arriving at the fair on July 17, 1893. Even though the exposition was in honor of Columbus's first landfall, it was common knowledge among scholars that Norsemen had sighted and eventually reached the shores of North America nearly 500 years before Columbus. (*Official Views of the World's Columbian Exposition.*)

Four

FOREIGN SITES AND BUILDINGS

Of the 46 nations represented at the World's Columbian Exposition, 19 constructed national buildings or pavilions at the fair. A few others had small headquarters, not shown on any map of the fair, and also had displays in the Great Buildings. The Foreign Buildings were located south and east of the North Pond and along the lakefront from an area near the Palace of Fine Arts south to the North Pier. The structures shown and described by the authors are ones they think are noteworthy for the way the architectural style mirrored the local style of the country represented; for example, Great Britain's Victoria House was constructed with half-timbered gables, Norway built a stave church–style building, Japan's Ho-o-den on the Wooded Island was a replica of a Japanese temple, and Germany's was in the style of an Old World town hall.

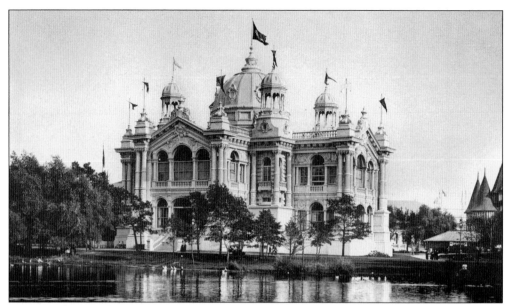

BRAZIL. The Brazil Building, arguably the most beautiful of the Foreign Buildings, featured one exhibit devoted to the coffees of Brazil, among other displays. The Neo-Manueline style of the building, capped with a 43-foot-high dome, echoed architecture that was used in many public buildings and private homes for the wealthy in mid-to-late-19th-century American cities. Lt. Col. F. de Lonza Aguiar was the architect of this structure. (*Official Views of the World's Columbian Exposition.*)

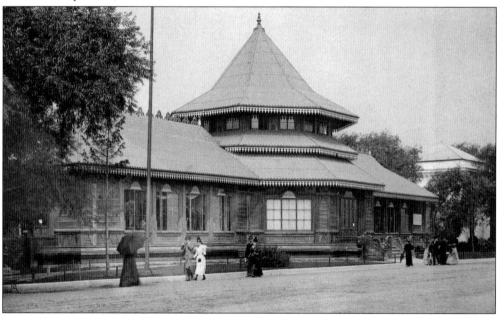

CEYLON. The Ceylon Building was designed by H.F. Tomalin of Ceylon. Natives of Ceylon constructed the pavilion to reflect the style and ornamentation indigenous to the island. On display inside the building were many products and arts, including teas, spices, and native hardwoods. Another feature from this country was the Ceylon Tearoom located in the Woman's Building. Today, this country is known as Sri Lanka. (*Official Views of the World's Columbian Exposition.*)

56

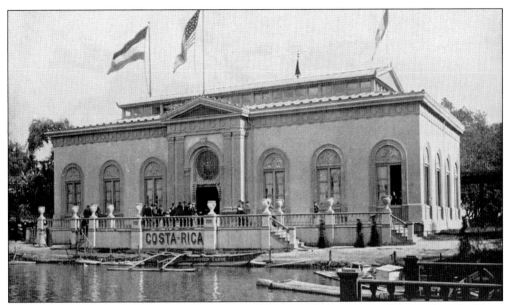

COSTA RICA. American architect James G. Hill designed the Classical Revival–style Costa Rica Building. One of Hill's earlier projects was overseeing the construction of the US Treasury Building in the District of Columbia. The exterior of the Costa Rica Building featured a terrace and balustrade facing the North Pond; the interior, lighted by clerestory windows, exhibited a wide variety fauna from the region. Additionally, there were many displays on the growing and processing of Costa Rican coffee. (Paul V. Galvin Library, Illinois Institute of Technology.)

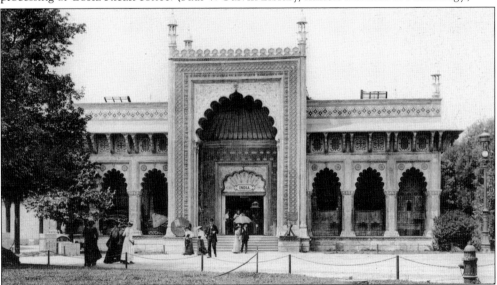

EAST INDIA. This was only Foreign Building designed by Chicago architect Henry Ives Cobb; the East India Pavilion was financed and built by Britain, as India was a part of the British Empire at this time. The design elements were inspired by the Taj Mahal and also included the carved figures seen on many Hindu temples. The interior, which was filled with the odors of a typical Indian market or bazaar, displayed brassware, cloths from different regions on the subcontinent, and items made of fragrant sandalwood, carpets, and other items. Tea was served to the fairgoers inside the East India Building. (*Official Views of the World's Columbian Exposition.*)

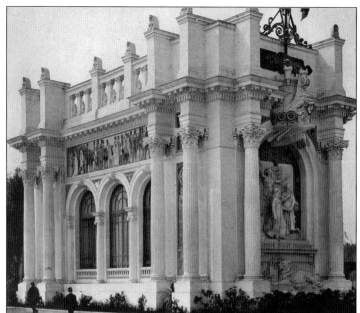

FRANCE. The French Pavilion, designed by the Paris firm of Motte & Dubuisson, was actually two structures connected by a gallery. The interior exhibited paintings of Paris and a display on the anthropometry method devised by French police officer Alphonse Bertillon of using physical measurements to identify criminals. His system was later replaced by the use of fingerprints for identification. (*Official Views of the World's Columbian Exposition.*)

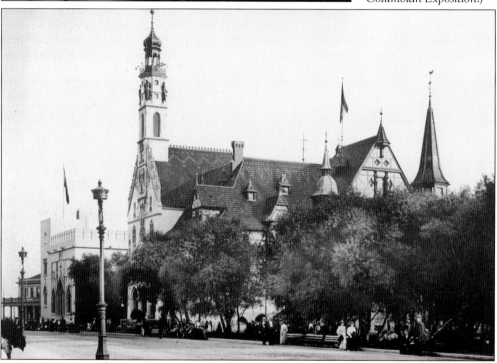

GERMANY. If the real estate mantra "location, location, location" means anything, then the German Building was the best-sited foreign pavilion at the exposition. The half-million-dollar structure located on the lakeshore featured nuances of color and decorative arts that mirrored the architecture of Medieval and Renaissance town halls. The interior and its furnishings were designed to resemble a church and exhibited valuable antique books and musical scores by famous German composers. The German Building was designed by a Berlin architectural firm. (*Official Views of the World's Columbian Exposition.*)

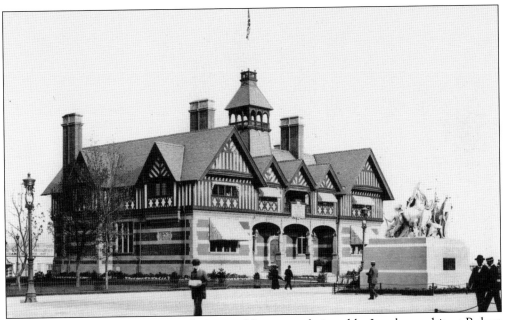

GREAT BRITAIN. The half-timbered Victoria House was designed by London architect Robert E. Edis and reflected Tudor heritage as well as design elements incorporated into homes during the Victorian era. Used mostly as a clubhouse for visiting British subjects, the interior with its fireplaces, displays of antiquities, and furnishings reflected English upper-class life. (*Official Views of the World's Columbian Exposition.*)

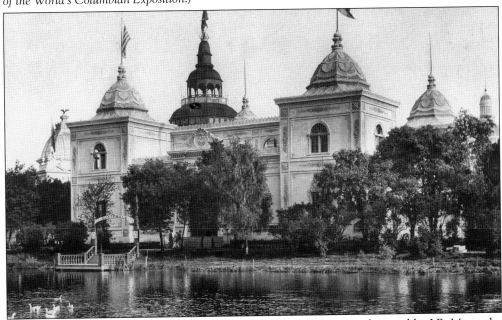

GUATEMALA. One of three exposition buildings of Central America designed by J.B. Mora, the Guatemala Building boasted an interior court and fountain. Indigenous flora and fauna were on display, as well as an exhibition of coffee growing and harvesting. Here, fairgoers could purchase and savor fragrant Guatemalan coffee while resting from the heat outside. (*Official Views of the World's Columbian Exposition.*)

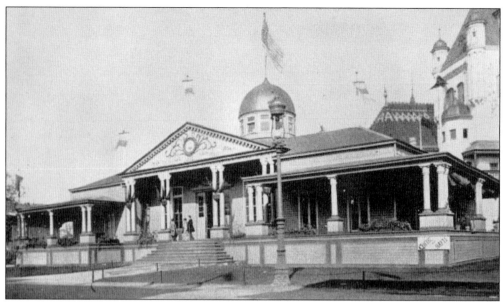

HAITI (SPELLED HAYTI IN 1893). In 1803, Haiti achieved its independence from France, and the presence of its pavilion at a world's fair was a singular achievement for this nation. When the Haiti Building, the creation of S.S. Child, was dedicated, former slave Frederick Douglass was the main speaker. Inside the structure, visitors saw displays commemorating Toussaint L'Ouverture, the George Washington of his country, who had fought against the French during the reign of Napoleon Bonaparte. (Paul V. Galvin Library, Illinois Institute of Technology.)

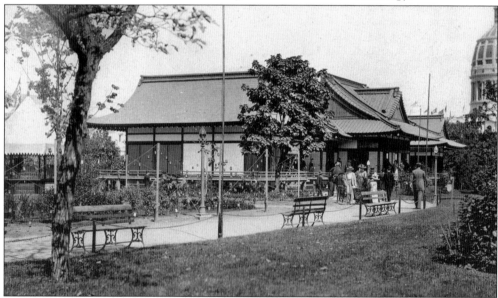

JAPAN. On the north end of the Wooded Island across the lagoon from the Horticultural Building was the Ho-o-den, a collection of three buildings set in the midst of a garden representative of Japanese landscape architecture. The Ho-o-den ("House like a Phoenix") was constructed to resemble the mythical bird that would rise from its own ashes if destroyed by fire. After the fair, the structure was donated to the city of Chicago. It was destroyed by fire in 1945. (*Official Views of the World's Columbian Exposition.*)

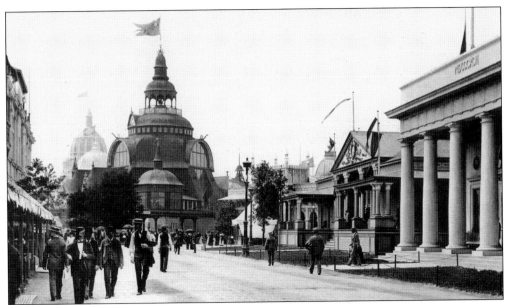

NEW SOUTH WALES, FAR RIGHT.
Although the building was erected
and named for New South Wales,
Australia's most populous state,
it shared its space with Australia,
the state of Queensland, and New
Zealand. These were also represented
by displays of wool and other products
and resources in some of the Great
Buildings. The building was designed
by the Chicago architectural firm of
Holabird & Roche. (*Official Views of
the World's Columbian Exposition.*)

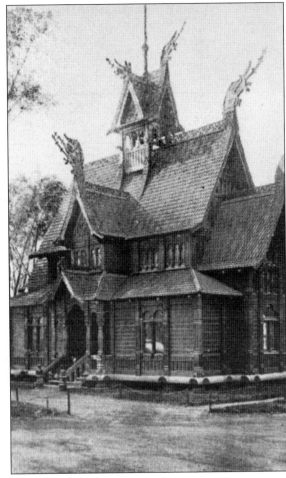

NORWAY. The Norway Building was
designed by a Norwegian architect
and first constructed in Norway,
disassembled, and reassembled at
the World's Columbian Exposition.
It was modeled after a *stavkirke*,
or stave church, a structure going
back to the medieval era. A close
look at the building's peaks reveals
dragon's-head motifs reminiscent
of those found at the prow and
stern post of a Viking ship. This is
one of the few surviving structures
of the fair and is now located at
Little Norway, in Blue Mounds,
Wisconsin. (Paul V. Galvin Library,
Illinois Institute of Technology.)

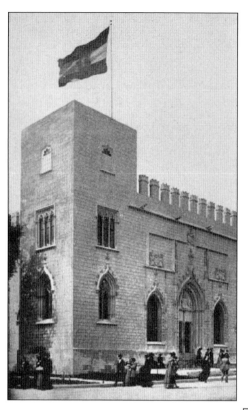

SPAIN. Designed to showcase the Spanish discovery of 1492, the Spanish Building displayed paintings and items associated with Ferdinand, Isabella, and Christopher Columbus. The structure was modeled after a building in Valencia contemporaneous with Columbus. The tower resembles a truncated and wholly unadorned version of the famous Giralda, a minaret altered into the campanile for the Cathedral of Seville. Rafael Gaustivino designed the building. (*Official Views of the World's Columbian Exposition.*)

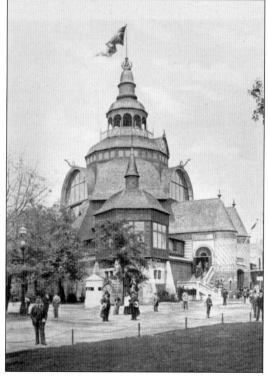

SWEDEN. Designed by Stockholm architect Gustaf Wickman, this structure was another building that was fabricated in the country of origin, disassembled, and reassembled on the grounds of the exposition. The whimsically designed structure was conceived in a style of a Swedish building from the 1500s. The exhibits featured a range of Swedish manufactures and an outdoor display of winter sports equipment. (Paul V. Galvin Library, Illinois Institute of Technology.)

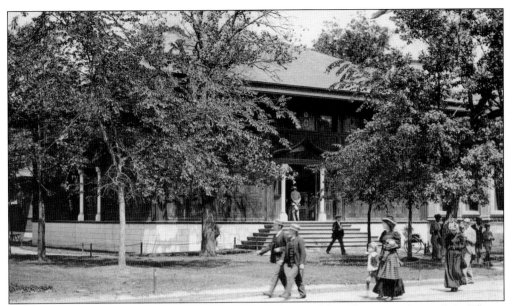

OTTOMAN PAVILION. The Ottoman Pavilion was designed by Chicago architect J.A. Thain, crafted in Syria, and assembled in Chicago. The exterior is carved with intricate designs in an Arabesque style. In the interior, exhibits such as embroidered silk, toiletry items, and perfumes and jewelry represented the products of the Ottoman Empire. Carpets and tapestries were also on display. (*Official Views of the World's Columbian Exposition*.)

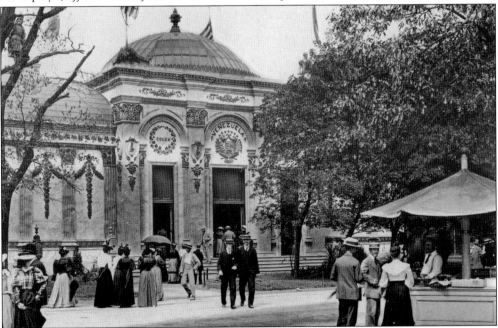

VENEZUELA. This building was another of the South American pavilions designed by J.B. Mora. One side of the building had a statue of Simon Bolivar, while the opposite side had one of Christopher Columbus. The interior exhibits included items from Venezuela's prehistory, relics from the time of the conquistadors, examples of flora and fauna, minerals and spices, arts and crafts, and, of course, coffee. (*Official Views of the World's Columbian Exposition*.)

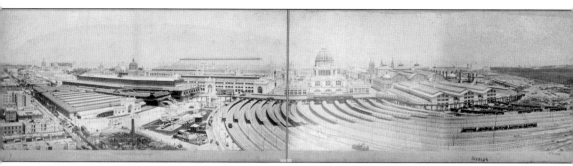

BIRD'S-EYE VIEW. Here is a sweeping view of the fairgrounds, dominated by the great dome. (Paul V. Galvin Library, Illinois Institute of Technology.)

Five

STATE SITES AND BUILDINGS

There were 37 State Buildings and one Territorial Building (for Arizona, New Mexico, and Oklahoma) at the World's Columbian Exposition. The State Buildings shown and described were selected by the authors for their architectural importance, often reflecting elements that encompassed the history of architecture in the nation's history. The architectural styles of these buildings varied and, in some cases, were evocative of the state they represented. For example, Pennsylvania erected a replica of Independence Hall that included the actual Liberty Bell, Massachusetts built a replica of the John Hancock house, Virginia created a copy of George Washington's Mount Vernon, and California built a Spanish Mission–style structure. In addition to the displays in the State Buildings, each of the states represented at the fair also mounted significant exhibits in many of the 14 Great Buildings, similar to the exhibiting countries.

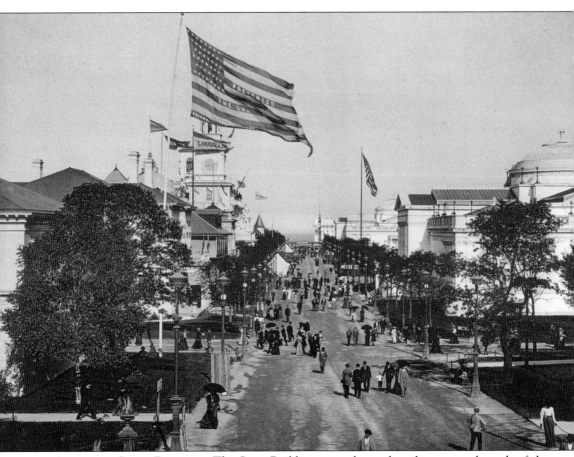

Avenue of State Building. The State Buildings were located to the west and north of the Palace of Fine Arts. The interiors of these buildings exhibited, among other things, historical items, natural resources, manufactured goods, and other local products. (*Official Views of the World's Columbian Exposition.*)

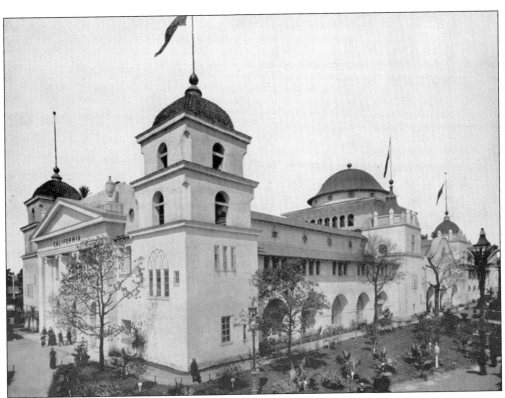

CALIFORNIA. The California Building was designed by San Francisco architect A. Page Brown and reflected the Mission-style architecture characteristic of the state. It had a roof garden and four corner bell towers resembling those of the early missions. Inside were exhibits highlighting the state's agricultural products, in particular oranges. Of the State Buildings, it was second in size to the Illinois Building. (Paul V. Galvin Library, Illinois Institute of Technology.)

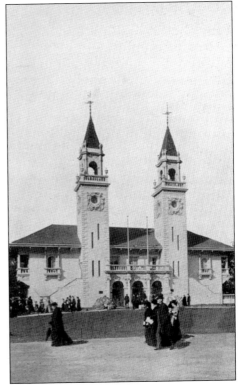

COLORADO. Denver architect H.T.E. Wendell designed the Colorado Building in the Spanish-Moorish style that was prevalent in parts of the West. In keeping with the mineral production in the state, the building was constructed of native materials. The columns and friezes on the exterior reflected the agriculture of the state, and the interior exhibits included minerals, agriculture, and the local flora and fauna. (Paul V. Galvin Library, Illinois Institute of Technology.)

FLORIDA. Like a few other states, Florida chose to replicate architecture from its past; although, in constructing a small-scale replica of the 17th-century Fort Marion (Castillo de San Marcos), it was the only state to erect a fort for its pavilion. The Florida Building exhibited examples of its agricultural produce and gardens of native flora. (Paul V. Galvin Library, Illinois Institute of Technology.)

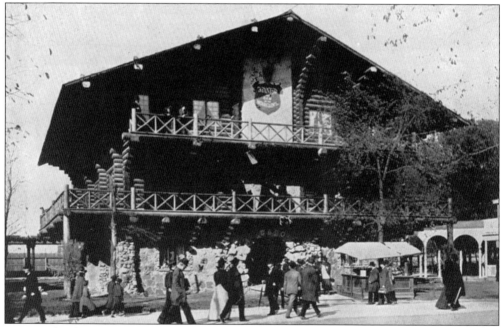

IDAHO. The three-story Idaho Building, designed by the architectural firm of Cutter & Poetz of Spokane, Washington, was built entirely of native lumber and used translucent mica for glazing the windows. Idaho was one of two states noted for the mining of mica, and it and other minerals were prominently displayed. (Paul V. Galvin Library, Illinois Institute of Technology.)

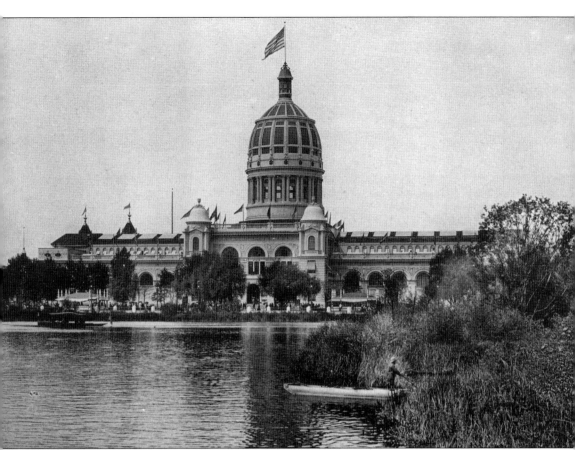

ILLINOIS BUILDING. The Illinois Building, located south of the North Pond, was the largest and costliest of all state and territory buildings. It was designed by W.W. Boyington and modeled somewhat after the Illinois State Capitol in Springfield that had been completed in 1889. Critics took aim at it because of its exceedingly tall dome that made the structure seem disproportionate next to the other State Buildings. (*Official Views of the World's Columbian Exposition.*)

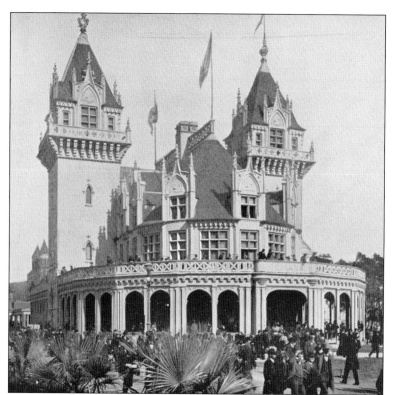

INDIANA. Another of Chicagoan Henry Ives Cobb's fair structures, the Indiana Building was designed in an eclectic style with strong Gothic Revival elements and red-roofed towers that contrasted nicely with the gray-colored exterior. On Indiana Day, one of the building's noted visitors was former president Benjamin Harrison, along with other Hoosier notables. (Paul V. Galvin Library, Illinois Institute of Technology.)

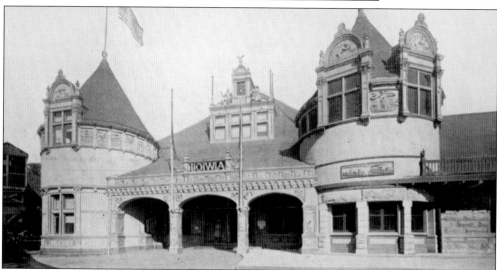

IOWA. Designed by the Cedar Rapids firm of Josselyn & Taylor, part of the Iowa Building had formerly served as the Daniel Burnham–designed Jackson Park Pavilion (1888) located on the lakefront. The architects chose to use a French Chateau style, which readily incorporated the existing structure. The original pavilion served as the "Corn Palace" of the Iowa exhibit, which featured corn and other grains, including a model of the state's capitol building. After the fair, the addition to the pavilion was removed, and the original portion of the structure was razed in 1936. The so-called Iowa Building currently on the site has no connection to the Columbian Exposition. (Paul V. Galvin Library, Illinois Institute of Technology.)

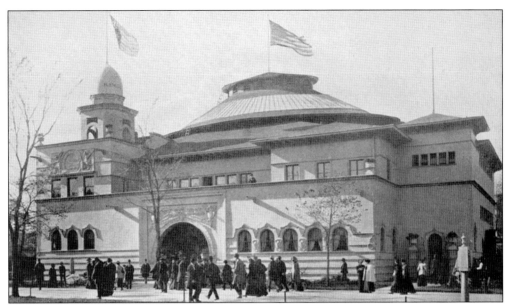

KANSAS. Topeka architect Seymour Davis designed the cruciform Mission-style Kansas Building, and it was constructed entirely out of native materials. In addition to serving as a clubhouse for notables and other visitors from Kansas, the interior exhibited agricultural products of the state and natural history displays that included many examples of the local fauna. (Paul V. Galvin Library, Illinois Institute of Technology.)

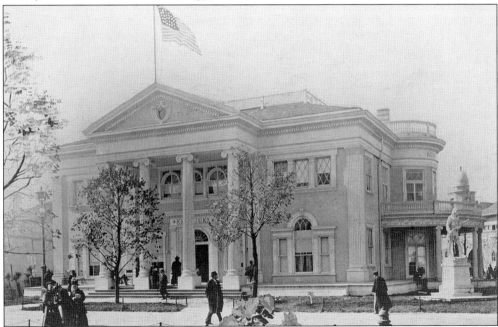

KENTUCKY. The Louisville firm of Maury & Dodd designed the Classical Revival–style Kentucky Building. Its displays included statues of its noted sons Daniel Boone and Henry Clay. The structure was evocative of southern mansions and their notable hospitality. The Kentucky displays prominently featured the tobacco and bourbon whiskey for which the state is famous. (Paul V. Galvin Library, Illinois Institute of Technology.)

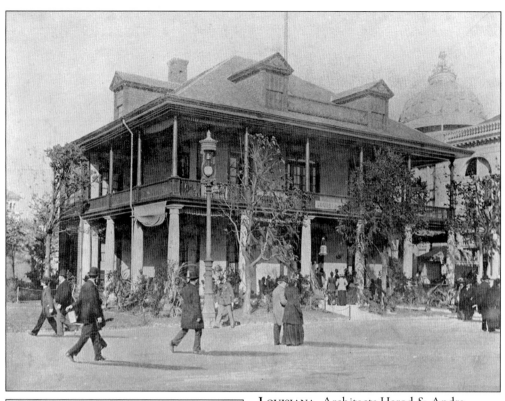

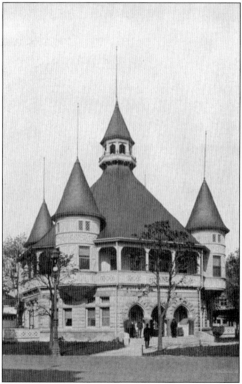

LOUISIANA. Architects Herod & Andre of New Orleans designed the Vieux Carre and plantation-inspired Louisiana Building. Visitors could feel that they were transported back to Louisiana's Spanish and French pasts and could sample the cuisine offered by a Creole café. The exhibits focused on the state's rich history, related artifacts, and its most notable agricultural products. (Paul V. Galvin Library, Illinois Institute of Technology.)

MAINE. Constructed of native granite, the Maine Building was the design of Maine native Charles S. Frost, who, at the time of the fair, worked in Chicago. It is one of the few structures from the World's Columbian Exposition that is still in existence, located today in Poland Spring, Maine, where it was moved after it was dismantled in Chicago. (Paul V. Galvin Library, Illinois Institute of Technology.)

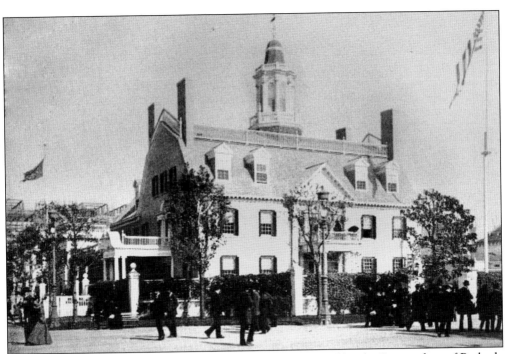

MASSACHUSETTS. Planned as a historical museum and designed by the Boston firm of Peabody & Stearns, the Massachusetts Building was a replica of the Beacon Hill colonial residence of Declaration of Independence signer John Hancock (the original was razed in 1863). Visitors could see many historical artifacts, including royal charters from the time of Charles I, furnishings, old books dating to 1620 when the Pilgrims landed, and other relics. (Paul V. Galvin Library, Illinois Institute of Technology.)

MICHIGAN. The Gothic-inspired Michigan Building was constructed of native materials and exhibited agricultural and mineral resources. Additionally, the interior featured a magnificent pipe organ and a natural history display. One room was finished by lumbermen in hardwoods native to Michigan. The Michigan Building was designed by the Detroit architectural firm of M.L. Smith & Son. (Paul V. Galvin Library, Illinois Institute of Technology.)

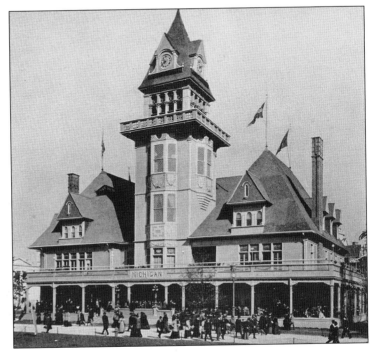

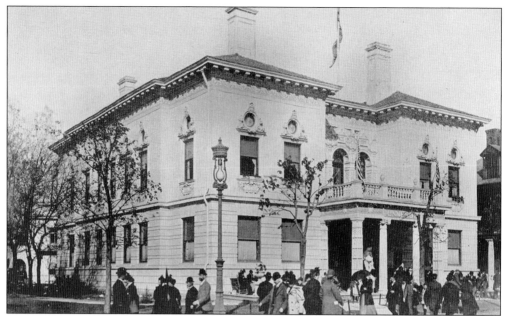

MINNESOTA. The Minnesota Building was designed by Minneapolis architect William Channing Whitney in the Italian Renaissance style. The "Land of 10,000 Lakes," as might be expected, featured a fisheries exhibit from the Minnesota Fish Commission. The schoolchildren of the state contributed their pennies, nickels, and dimes for the sculpture of Hiawatha that graced the outside of the building. (Paul V. Galvin Library, Illinois Institute of Technology.)

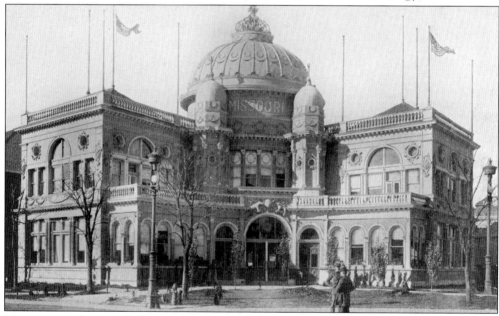

MISSOURI. Architect L.S. Curtis of Kansas City designed the Missouri Building in the Spanish Renaissance style. Missouri was one of the states also represented in the Great Buildings, with exhibits in Mines and Mining, the Agricultural, Electricity, Horticultural Buildings, and Machinery Hall. The Missouri Building itself had a beautifully decorated interior and exhibited Missouri's many mineral resources. (Paul V. Galvin Library, Illinois Institute of Technology.)

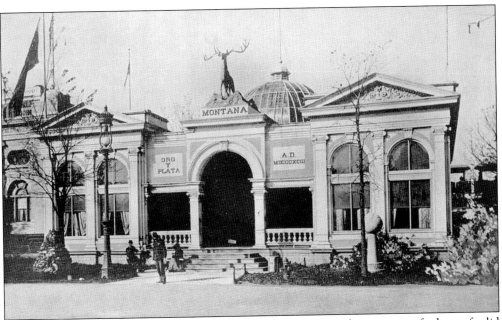

MONTANA. Montana's more spectacular displays such as a statue of a woman crafted out of solid silver ("the silver queen") were in the Mines and Mining Building. The architectural firm of Gallbraith & Fuller designed the Classical Roman-style State Building for Montana. The building itself had displays of minerals and mining, including tools and other items. (Paul V. Galvin Library, Illinois Institute of Technology.)

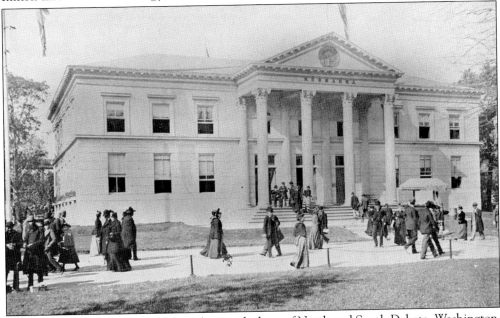

NEBRASKA. The Nebraska Building, along with those of North and South Dakota, Washington, and the Esquimaux Village, overlooked the Northwest Pond. It was designed by Henry Voss of Omaha. Since Buffalo Bill's Wild West Show was being performed during the exposition and directly outside of the fairgrounds, Buffalo Bill, along with members of his show, were on hand for the dedication of the building. (Paul V. Galvin Library, Illinois Institute of Technology.)

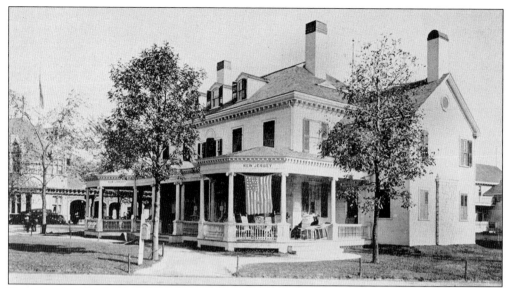

NEW JERSEY. Charles Alling Gifford of Newark designed the Colonial-style house to represent the Jacob Ford Mansion in Morristown, which was George Washington's quarters during the winter of 1779–1780. Although some of the exhibit space was devoted to New Jersey's products and manufacturing, most of the interior was a museum of the period of the American Revolution. Included were reproductions of Washington's bedroom and furnishings. (Paul V. Galvin Library, Illinois Institute of Technology.)

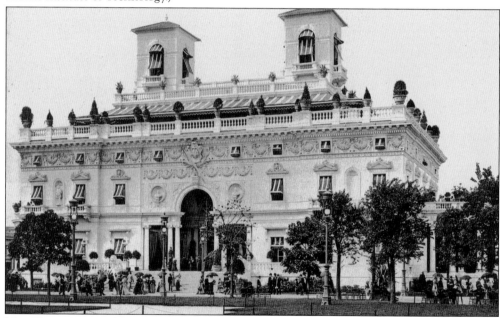

NEW YORK. Designed by McKim, Meade & White of New York, who also were responsible for the Agricultural Building, the New York Building was meant to be a reproduction of the Van Rensselaer Mansion, a New York City landmark. Displayed within were many historical artifacts associated with the state, including a model of Fulton's *Clermont*, portraits of famous New Yorkers, and autographs of presidents and signers of the Declaration of Independence, and other items from the colonial and revolutionary eras. (*Official Views of the World's Columbian Exposition.*)

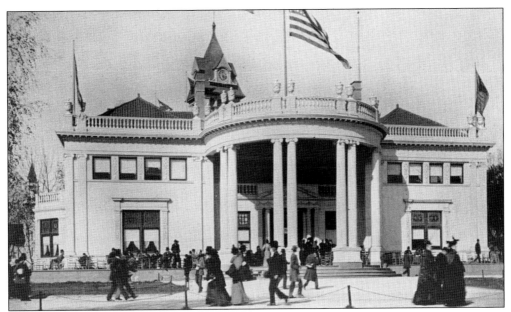

OHIO. The Ohio Building was designed by Cincinnati architect James W. Laughlin in a Classical Revival style. Near the entrance was a large memorial shaft around which were statues of Ulysses S. Grant, William T. Sherman, Salmon P. Chase, Edwin M. Stanton, and other Ohio notables. The building served mainly as a place for visiting Ohioans; therefore, the interior did not display state products. (Paul V. Galvin Library, Illinois Institute of Technology.)

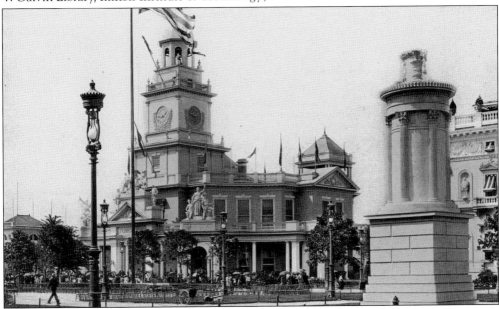

PENNSYLVANIA. The Pennsylvania Building, designed by Philadelphia architect Thomas P. Lonsdale, was a reproduction of Independence Hall. One of the chief attractions at this building was the original Liberty Bell. Also on exhibit were items closely associated with William Penn, Benjamin Franklin, George Washington, and Thomas Jefferson, historical artifacts used in writing and signing the Declaration of Independence, and other relics. (*Official Views of the World's Columbian Exposition.*)

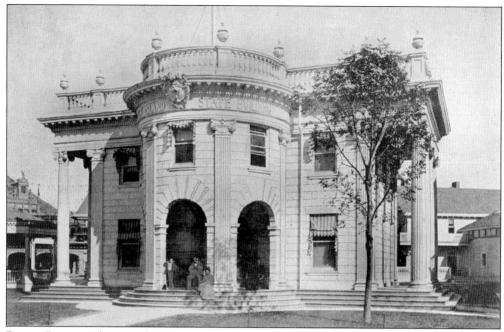

RHODE ISLAND. The Providence architectural firm of Stone, Carpenter & Wilson designed the Rhode Island Building in a Classical Greek style. There is little description of the state products, if any, that were on display in the building; however, the state was represented in departments at other locations on the fairgrounds. (Paul V. Galvin Library, Illinois Institute of Technology.)

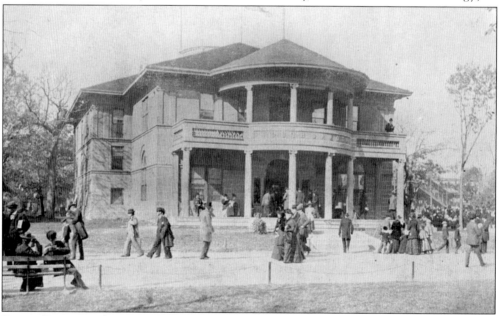

SOUTH DAKOTA. The somewhat Romanesque-style South Dakota Building was designed by architects Van Meter & Perman of Aberdeen. The exhibits included fossils, minerals, and an array of grains and other products of agriculture. South Dakota was also represented in the Horticultural Building, the Stock Pavilion, and other locations at the exposition. (Paul V. Galvin Library, Illinois Institute of Technology.)

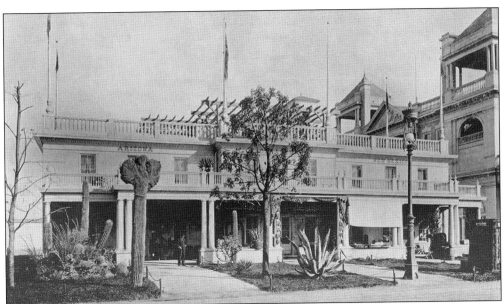

"TERRITORIES"—ARIZONA, NEW MEXICO, AND OKLAHOMA. Designed by architect Seymour Davis of Topeka, Kansas, the Territories Building had a roof garden with a sheltering cover that displayed the flora of New Mexico and Arizona. The archaeological and current exhibits on the indigenous peoples of the desert southwest and displays of gold, silver, turquoise, and minerals, were impressive. Oklahoma's displays were smaller and related to the state's agriculture. (Paul V. Galvin Library, Illinois Institute of Technology.)

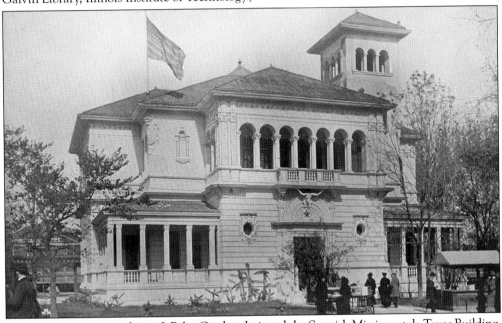

TEXAS. San Antonio architect J. Riley Gordon designed the Spanish Mission–style Texas Building. There are few descriptions of the interior exhibits except for what is found in an 1893 fair guide, which describes it to have "special exhibits of great interest, and thousands of curiosities and relics." Statues of Stephen Austin and Sam Houston also graced the interior. Private citizens contributed the funds for this structure. (Paul V. Galvin Library, Illinois Institute of Technology.)

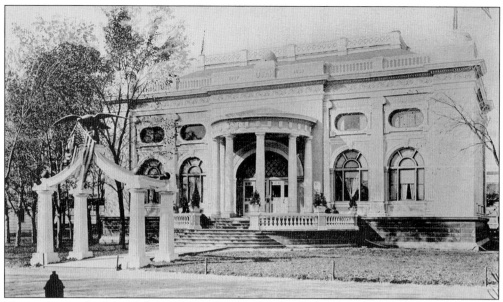

UTAH. A reproduction of the Eagle Gate to the Mormon Temple in Salt Lake City welcomed visitors to the Utah Building; a statue of Brigham Young was also on display. The interior displays were of the territory's agricultural, manufacturing, and mining products. Also exhibited was a large taxidermy display of local fauna. Dalles & Hedges of Salt Lake City designed the Utah Building. (Paul V. Galvin Library, Illinois Institute of Technology.)

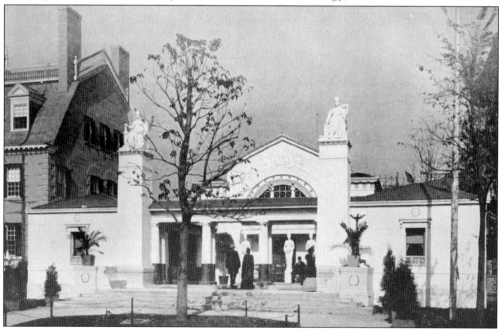

VERMONT. The Vermont Building was another of the state structures that did not display its products and industries but only used carved figures to represent them. However, Vermont's marble and granite quarrying industry was exhibited in the Mines and Mining Building. The Roman-style building with its marble fountain in the central courtyard was designed by Vermont architect Jarvis Hunt. (Paul V. Galvin Library, Illinois Institute of Technology.)

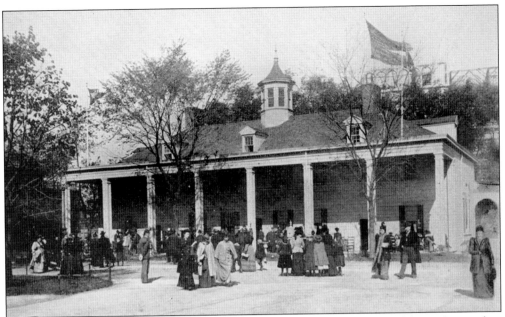

VIRGINIA. Architect Edgerton Rogers of Richmond designed the Virginia Building to be a replica of Mount Vernon, the home of George Washington. Both the exterior and interior faithfully reproduced how the building looked in Washington's time. The interior displayed both copies and original furnishings of the estate, including even the fireplace mantels and silver service used in the dining room. (Paul V. Galvin Library, Illinois Institute of Technology.)

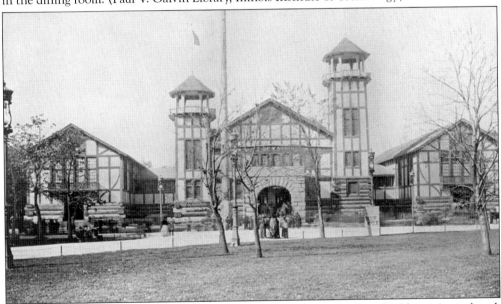

WASHINGTON. The State of Washington had displays in many of the Great Buildings: Agricultural, Mines and Mining, Forestry, Fisheries, Transportation, and the Woman's Building. Its half-timbered State Building was designed by architect Warren P. Skillings of Seattle. All of the building materials were native to Washington and reflected the importance of the timber industry to the state. The flagpole outside of the building was a single 238-foot piece of timber. (Paul V. Galvin Library, Illinois Institute of Technology.)

WEST VIRGINIA. The West Virginia Building was designed by Chicago architect J.L. Silsbee, who also was responsible for the North Dakota Building. Native hardwoods were used in its construction, including in the interior design elements. An interesting historical relic displayed in the building was the sofa on which Grant and Lee arranged the surrender of the latter's army in the McLean House at Appomattox Courthouse, Virginia. (Paul V. Galvin Library, Illinois Institute of Technology.)

WISCONSIN. The Wisconsin Building was evocative of many of the large homes found in Chicago, Oak Park, and throughout the Midwest. The exterior was built of the brownstone, brick, and hardwoods so popular in the construction of large residences of the time. The building was designed by architect William Waters of Oshkosh. One of Wisconsin's contributions to the exposition was the Milwaukee-built Allis-Corliss engine located in Machinery Hall, which transmitted power to the dynamos that provided electrical power to the exposition. (Paul V. Galvin Library, Illinois Institute of Technology.)

Six

MIDWAY PLAISANCE

The Midway Plaisance was a nearly mile-long area separate from the main fairgrounds. It featured exotic exhibits, the first Ferris Wheel, and other entertainments. This area was also meant to educate fairgoers about nonwestern cultures in ways that combined knowledge and entertainment. The midway had its own separate admission tickets. According to one of the 1893 guidebooks, many attractions offered free admission; others charged anywhere from 10¢ to 25¢, with a few setting a slightly higher entrance price.

Some of the attractions on the midway included, besides the original Ferris Wheel, various European, African, and Asian ethnic villages and encampments; shows, including "Little Egypt" and her dance; rides; music; reproductions of famous world landmarks; animals; reconstructions of temples and palaces; sounds and smells new to many fairgoers; a variety of dining experiences; and souvenirs. Some manufacturers had exhibits on the midway, including Libbey Glass, the Diamond Match Company, the Adams Express Company, and the Venice Murano Company.

Other attractions that a fairgoer would find on entering the midway from the west entrance and walking to the right side were a Bedouin encampment; the Lapland and Dahomey villages; Old Vienna; the Ferris Wheel, located in the center of the midway; a Moorish palace; a Turkish village; a panorama of the Bernese Alps; South Sea and Samoan islanders; the Hagenbeck Animal Show; and a railroad station. A fairgoer who used the west entrance and walked to the left side would find the Brazilian Music Hall; a replica of Sitting Bull's camp, where he was killed in 1890; an ostrich farm; a captive balloon; a Chinese village and theater; a panorama of the volcano Kilauea; an Indian bazaar; the Algeria and Tunisia exhibit; the Cairo street; German and Irish villages; and the Javanese settlement.

The images and captions to follow are only a sample of the 53 attractions that were located on the midway.

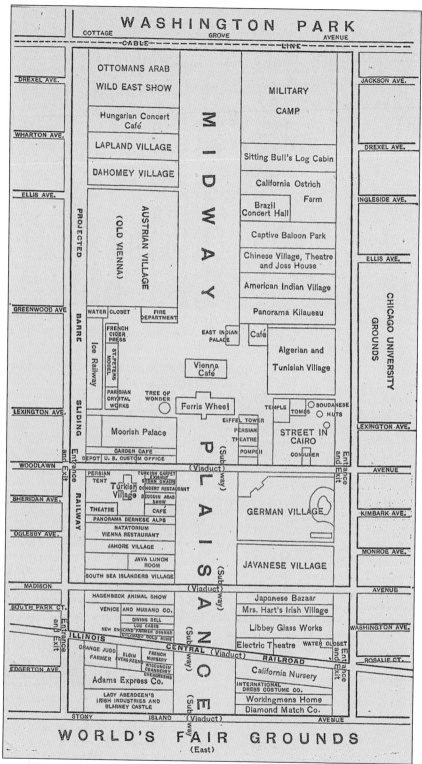

MAP OF THE MIDWAY. Pictured here is a map of the popular midway. (Di Cola collection.)

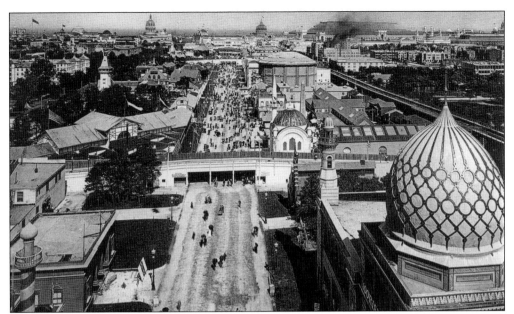

VIEW OF MIDWAY FROM THE FERRIS WHEEL, LOOKING EAST. This attraction and the Vienna Café were the only ones located in the center of the Midway Plaisance. (*Official Views of the World's Columbian Exposition.*)

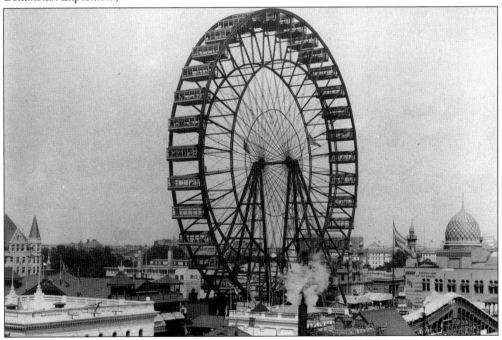

FERRIS WHEEL. Invented and designed by George Washington Gale Ferris, the Ferris Wheel was the first ever. It was planned to be Chicago's rival answer to the Eiffel Tower at the 1889 Paris Exposition—although it was only one-fourth of the height of the latter. Its axle alone weighed 70 tons. A million and a half visitors rode the 250-foot-tall Ferris Wheel, which could accommodate 2,160 people in 36 cars holding 60 people each. (*Official Views of the World's Columbian Exposition.*)

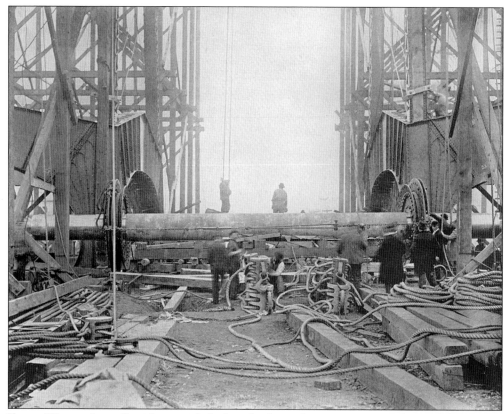

FERRIS WHEEL, AXLE. Ferris's principle for his wheel was the tension in its spokes and the support this provided, which in turn was supported by the axle big enough to carry 2,000 tons. To keep the wheel from collapsing, the axle had to be of exceptional integrity and strength. The axle was a solid shaft 32 inches in diameter, 45 feet long, and weighing 70 tons. The above image shows it as it is set to be raised to the top of the towers. Below, fairgoers enjoy the sites of the midway as the Ferris Wheel looms in the background. (Above, Paul V. Galvin Library, Illinois Institute of Technology; below, Library of Congress.)

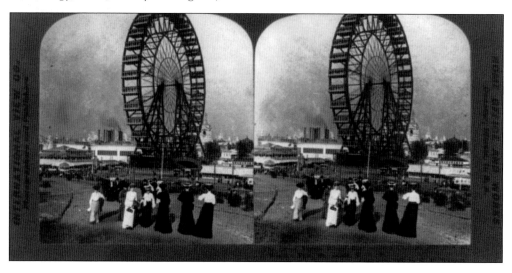

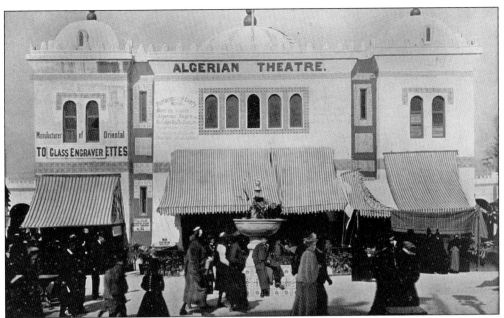

ALGERIA AND TUNISIA. The Algerian and Tunisian Village, designed by architect Alexander Sandier of Paris, was located just northwest of the Ferris Wheel. The village featured Algerian and Tunisian items for sale, a museum, and a café. The theater offered music and a variety of exotic acts, the dancing girls being the most popular. Unlike some other of the midway dancers, these women were fully clothed. (Paul V. Galvin Library, Illinois Institute of Technology.)

BEDOUIN ENCAMPMENT. The Bedouin Encampment was located at the western entrance to the midway. The Bedouin, an Arab ethnic group, live a nomadic existence as desert dwellers in North Africa and the Middle East, and their way of life was recreated in the enclosed encampment with its tents, indigenous costumes, and camels with their distinctive saddles and various accoutrements. Visitors were treated to dances, music, and other entertainments. (*Official Views of the World's Columbian Exposition.*)

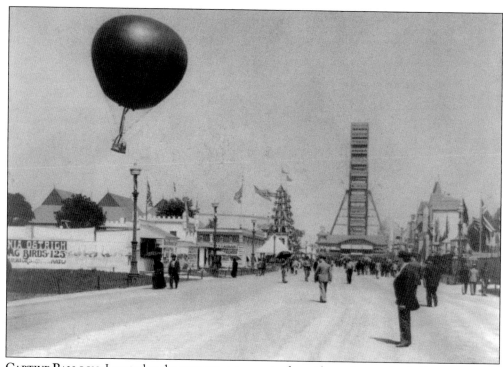

CAPTIVE BALLOON. Located at the western entrance to the midway, the captive balloon attraction provided a tethered ride in a hot air balloon that soared 1,500 feet above the fair providing a spectacular view of the main fairgrounds. When a windstorm caused a mishap and damaged the balloon, the ride closed for the duration of the fair. Below, fairgoers wait their turn for a balloon ride. (Both, Library of Congress.)

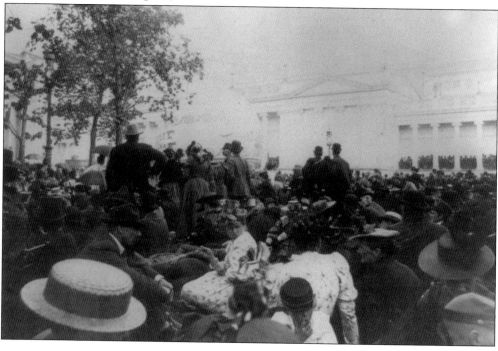

CHINESE VILLAGE AND THEATER. Just east of the captive balloon was the Chinese Village and Theater. Although not a commercial success and put into receivership at the end of the fair, the attraction also included a Joss House, or Shenist Chinese folk temple (pictured here), for the worship of shen (gods or ancestors). The theater offered Chinese entertainments. (Paul V. Galvin Library, Illinois Institute of Technology.)

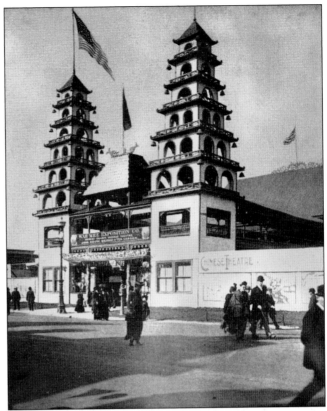

DAHOMEY VILLAGE. Dahomey was a small country in West Africa that became part of the French colonial empire in 1894, gained independence in 1960, and is now called Benin. The midway's Dahomean exhibit, located opposite the captive balloon site, was planned to showcase Dahomean life in Africa, including various daily tasks and dance performances by men. (*Official Views of the World's Columbian Exposition*.)

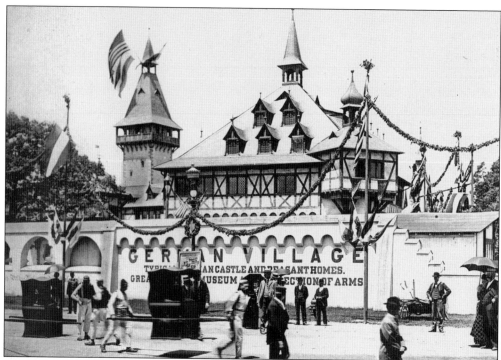

GERMAN VILLAGE. Having the largest footprint on the midway, the German Village was located about halfway down on the north and was largely evocative of Bavaria and its culture. It included 36 buildings, with one being a castle with moat, designed to replicate the medieval architecture of villages. Bands played, restaurants served German cuisine, and there was plenty of beer to drink, served up by zaftig maidens. (Both, *Official Views of the World's Columbian Exposition*.)

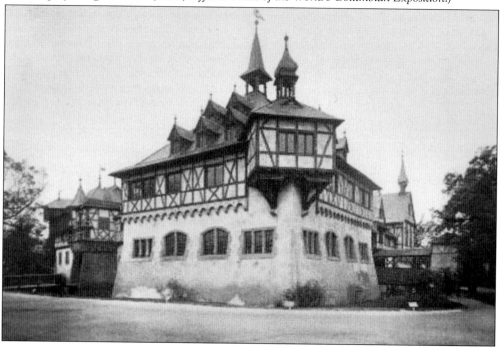

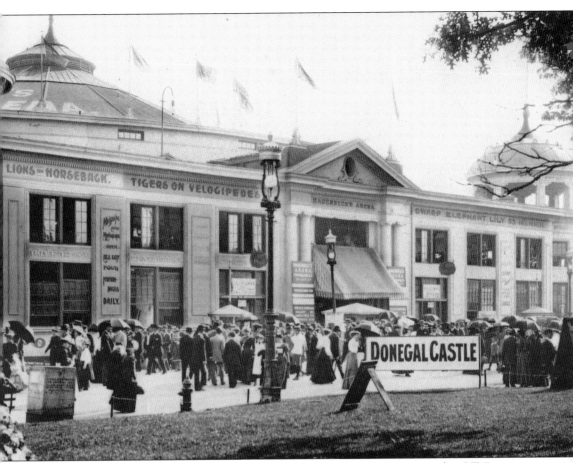

HAGENBECK ANIMALS. Carl Hagenbeck sold wild animals to zoos in Europe and to P.T. Barnum and was considered the father of the modern zoo. Located on the south side of the midway and west of the Illinois Central Railroad tracks, the eponymous attraction had a central circular caged arena where lions and other animals performed as in a circus. Surrounding the center portion of the building, visitors could view a virtual menagerie of caged animals. An open-air cage above the entrance also displayed lions. (*Official Views of the World's Columbian Exposition.*)

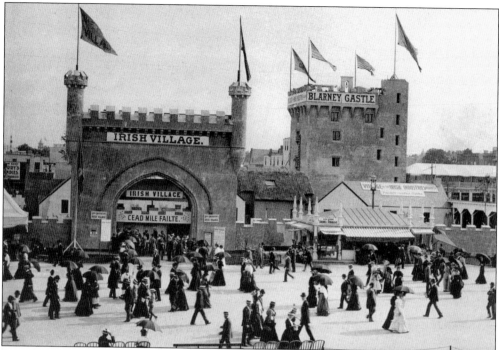

IRISH VILLAGE AND BLARNEY CASTLE. With its stone and thatched-roofed houses and a castle, the Irish Village transported fairgoers back to the Emerald Isle. The cottages were used as shops where Irish goods and souvenirs were sold and where one could find museum displays on Irish history and other exhibits. The village included replicas of Blarney Castle, where at the top of the tower a visitor could kiss the fabled Blarney Stone and an abbey cloister. The entrance to the Irish Village is pictured below. (Both, *Official Views of the World's Columbian Exposition.*)

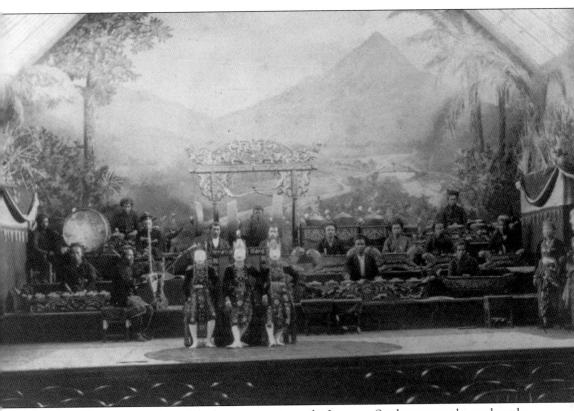

JAVANESE SETTLEMENT. One of the larger attractions, the Javanese Settlement was located on the north side of the midway immediately east of the German Village. Its educational value rivaled that of the Anthropological Building and grounds. The structures were built on stilts and closely resembled houses in the native land designed in this manner to prevent snakes and insects from entering and to provide for airflow in the house. A Javanese coffeehouse offered a respite from the hurly-burly of the midway. A Javanese theater, pictured here, offered musical entertainment. (Library of Congress.)

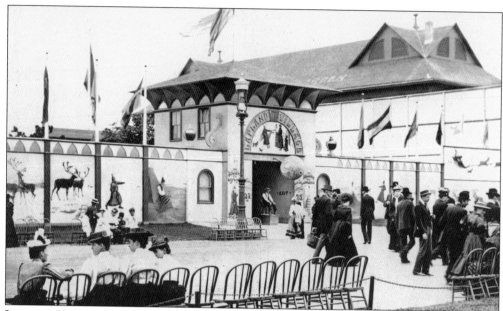

LAPLAND VILLAGE. The Lapland Village was located to the west of the Dahomey Village. Lapp homes for both winter and summer residence were exhibited in the village, as were reindeer, dogsleds, tanning of hides, Lapp clothing, and various arts and crafts. One of the Laplanders was purported to be over 100 years of age. The only other exhibit of Arctic peoples was the Esquimaux Village at the far northwest corner of the fairgrounds. (*Official Views of the World's Columbian Exposition.*)

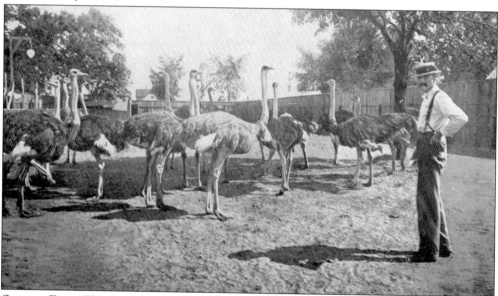

OSTRICH FARM. The Ostrich Farm was located just west of the captive balloon. Fairgoers learned about the habits of this largest of extant birds, including how to spot the difference between males (black plumage and pinkish skin) and females (gray plumage and drab-colored skin). Visitors also learned about gender differences in the habits of these birds. It is hoped that the presenter dispelled the myth of ostriches burying their heads in the sand. (Paul V. Galvin Library, Illinois Institute of Technology.)

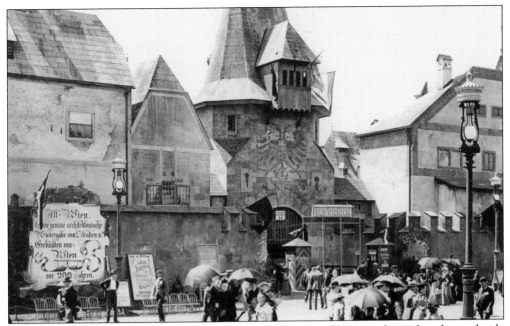

OLD VIENNA. Another of the exhibits with a large footprint was Old Vienna, located on the south side of the midway and southwest of the Vienna Café and Ferris Wheel. It was designed to represent Vienna in past centuries, and if any attraction lived up to its name, this one certainly did. Its houses were arrayed around a central town square with a bandstand where the visitors could enjoy music. (*Official Views of the World's Columbian Exposition.*)

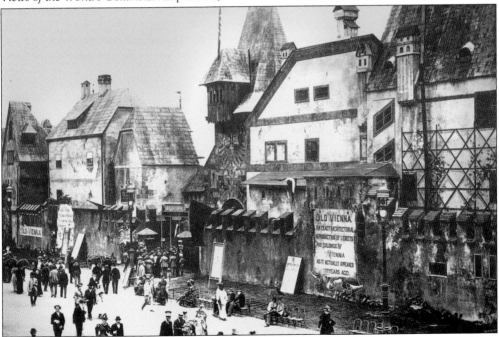

OLD VIENNA. Old Vienna was a reconstruction of an actual street in Austria, as it would have looked at the end of the 18th century. Shops offered Viennese goods, and an outdoor restaurant served bountiful food and beer. (*Official Views of the World's Columbian Exposition.*)

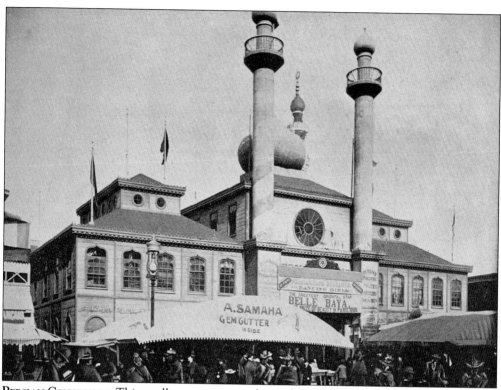

PERSIAN CONCESSION. This smaller attraction was located northeast of the Ferris Wheel. The idea was for the Persian Concession to serve as an educational exhibit where visitors learned about the arts and crafts and manufactures of Persia, like the weaving of rugs. The Street in Cairo, with its manifold sights to lure fairgoers, was situated next to and behind the Persian Concession and overshadowed the latter. (Paul V. Galvin Library, Illinois Institute of Technology.)

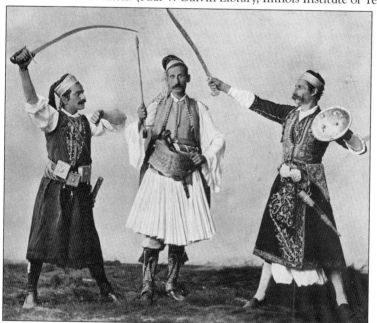

PERSIAN CONCESSION, SWORD DANCERS. The dancers, complete with swords and shields, performed to music of a drum and wind instrument. The central figure served as a referee while the dancers thrust, parried, and postured through their dance. (Paul V. Galvin Library, Illinois Institute of Technology.)

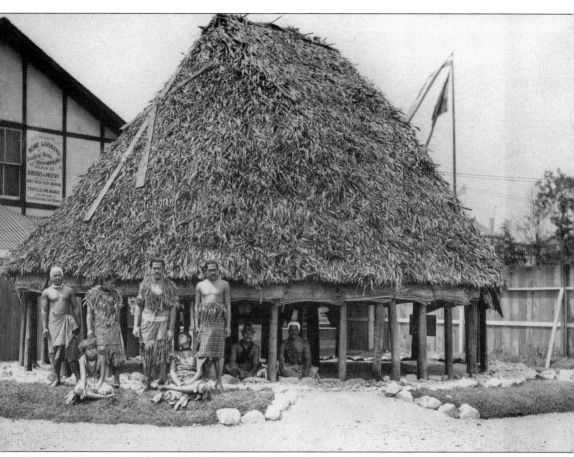

SAMOAN VILLAGE. On the south side of the midway and across from the Javanese Settlement were two Pacific Islander attractions. One of these was the Samoan Village, which featured the thatched, high-roofed, open-sided houses found on the island. The Samoan people in the village wore traditional garb that concealed less than 19th-century women usually experienced. The same could be said about the dancing, which, accompanied by native music, was the chief attraction. (*Official Views of the World's Columbian Exposition.*)

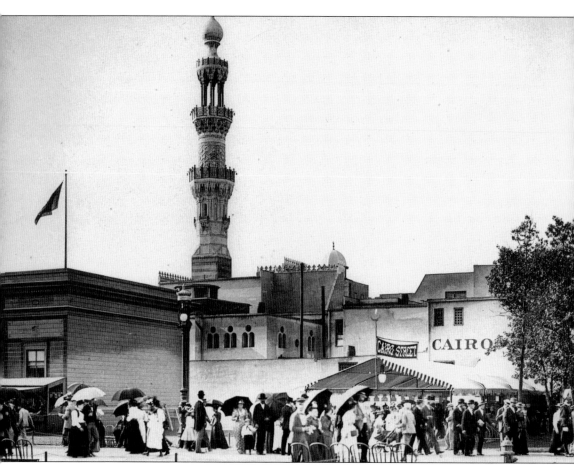

STREET IN CAIRO. On the Street in Cairo, one feature was the controversial dancer Little Egypt, and she was arguably the most popular attraction on the midway. It was located on the north side between Algeria and Tunisia and the German Village. Egyptian food and sweets were available as well as rides on a camel and shopping in the bazaars. The renowned 18th Dynasty Temple of Luxor and obelisks were replicated, offering fairgoers a glimpse into Egypt's wondrous past. A daily pageant involving "priests of Isis" and chanted songs added to the illusion. (*Official Views of the World's Columbian Exposition.*)

STREET IN CAIRO, TEMPLE OF LUXOR. The reproduction of the temple was located at the western end of the Street in Cairo. Displayed inside were replicas of recently discovered mummies of Seti I and other Egyptian pharaohs. At times during the day and evening, fairgoers were treated to a procession evocative of the religious observances of ancient Egypt, which included costumed priests of Isis; musicians playing harps, lutes, drums, and recorders; and a small statue of Apis. (Paul V. Galvin Library, Illinois Institute of Technology.)

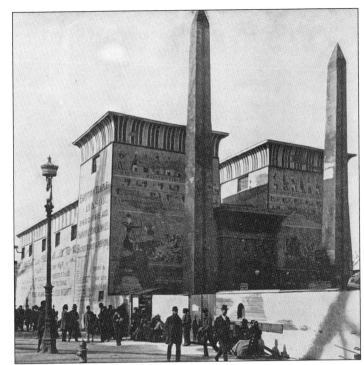

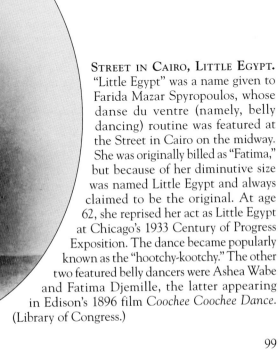

STREET IN CAIRO, LITTLE EGYPT. "Little Egypt" was a name given to Farida Mazar Spyropoulos, whose danse du ventre (namely, belly dancing) routine was featured at the Street in Cairo on the midway. She was originally billed as "Fatima," but because of her diminutive size was named Little Egypt and always claimed to be the original. At age 62, she reprised her act as Little Egypt at Chicago's 1933 Century of Progress Exposition. The dance became popularly known as the "hootchy-kootchy." The other two featured belly dancers were Ashea Wabe and Fatima Djemille, the latter appearing in Edison's 1896 film *Coochee Coochee Dance*. (Library of Congress.)

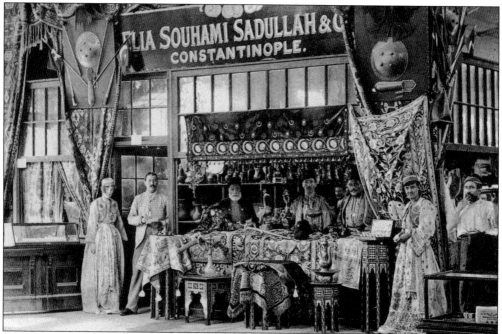

TURKISH VILLAGE. The Turkish Village was located on the south side of the midway across from the German Village and featured different aspects of Turkish culture; although, what was considered Turkish on the midway was more an eclectic mixture of elements from the Middle East rather than from the Ottoman Empire. Fairgoers could sample exotic drinks crafted from various fruits, try thick and intensely flavorful coffee, smoke hookahs, and view various exhibits and entertainments. (*Official Views of the World's Columbian Exposition.*)

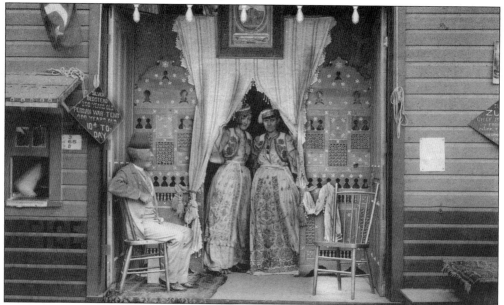

TURKISH VILLAGE. In the Turkish Village, visitors also saw plays performed by people from Turkey as well as throughout the Middle East. Part of the exhibits included mosques and houses typical of Turkish architecture. (*Official Views of the World's Columbian Exposition.*)

Seven

WORKS OF ART
AT THE EXPOSITION

The largest concentration of art at the World's Columbian Exposition was housed in the Palace of Fine Arts, with works donated by countries in America, Europe, and Asia, and included paintings and drawings in a variety of media, including sculptures, architectural renderings and castings, and carvings. The interior of the Woman's Building was decorated with murals painted by Mary Cassatt, and the exteriors and interiors of many of the Great, Foreign, and State Buildings also featured works of art. As visitors traversed the fairgrounds, they encountered other works of art, like statues of people and animals, fountains, bridges, and the use of art and architectural elements in both exhibits and landscaping.

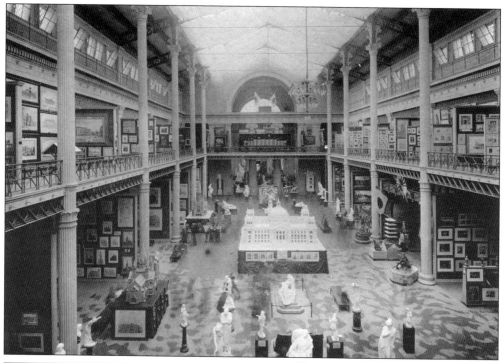

PALACE OF FINE ARTS, INTERIOR GALLERY. This interior gallery is representative of what visitors saw in the Palace of Fine Arts. Displays included sculpture, paintings, carvings and engravings, and represented art from many parts of the world. On the ground floor were architectural models of churches and palaces, as seen in this image. The walls on the lower level and in the mezzanine galleries were covered with paintings from various countries; sculptures were displayed on tables and pedestals.

SOAP BUBBLES. This painting by Elizabeth Gardner of Paris was exhibited in Gallery I in the Palace of Fine Arts. (Paul V. Galvin Library, Illinois Institute of Technology.)

THE OVERTHROW. This painting, by Rosa Bonheur, was also possibly named *Cows and Sheep in a Narrow Road.* Bonheur became one of the top female painters of her era, despite going against the styles of the time by painting the relatively unattractive and uncivilized scenes of animals as they naturally appeared. (Paul V. Galvin Library, Illinois Institute of Technology.)

MAN WITH A HOE. This painting was one of seven by Frenchman Jean-François Millet that appeared at the fair. Millet was one of the founders of France's Barbizon School movement, which moved away from the then popular Romantic movement towards Realism. While Millet died in 1875, his work was prominently displayed at the fair, and his legacy endures today—he served as an inspiration to both Von Gogh and Dalí, is the protagonist in Mark Twain's play *Is He Dead?*, and inspired Edwin Markham's famous poem "The Man with the Hoe." (Paul V. Galvin Library, Illinois Institute of Technology.)

ON THE YACHT NAMOUNA. Painted by American Julius Stewart, this work symbolizes the incredible wealth being created in the west and the resulting opportunities for leisure through activities such as yachting. Stewart himself was a product of this wealth: his father was a sugar industrialist who moved his family from Philadelphia to Paris, which allowed young Julius to indulge in his art. Many of his works showed similar themes and included celebrities, aristocrats, and actresses (such as Lillie Langtry, who appears on the Namouna's deck). (Paul V. Galvin Library, Illinois Institute of Technology.)

CUPID AND PSYCHE. This painting from the French studio of Lionel Royer is an example of the daring art of the time, which eschewed modesty by showing nudity and often included brilliant colors and leaned towards realism. (Paul V. Galvin Library, Illinois Institute of Technology.)

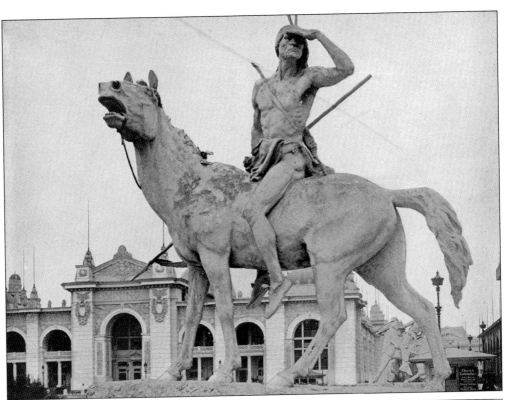

PROCTOR'S *THE INDIAN*. Facing the lagoon were two statues by Alexander Phimister Proctor, *The Indian* (foreground) and *The Cowboy* (background). Red Cloud, a chief of the Oglala Lakota (Sioux) tribe and also part of Buffalo Bill's Wild West Show, served as the model for this statue. Proctor, who was born in Canada but raised in Colorado, became one of North America's top monumental sculptors, and his grandson opened a museum of Proctor's works outside of Seattle in 1997. (Paul V. Galvin Library, Illinois Institute of Technology.)

THE ALBERT MEMORIAL. Commissioned by Queen Victoria and completed in 1872, a colossal memorial to Prince Albert sits in London's Kensington Gardens. At the four corners of the memorial are statues representing Europe, Asia, Africa, and America. A reproduction of *America* was created for the fair and was located in front of the British Victoria House. (Paul V. Galvin Library, Illinois Institute of Technology.)

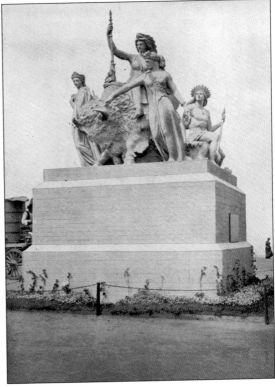

ON THE BRINK OF THE WELL. Frederic Montenard's *On the Brink of the Well*, depicting young love in a rural setting, appeared in the Palace of Fine Arts and. Like Bonheur and Millet, Montenard often showed animals as they appeared unadorned in nature, with or without humans. Montenard also exhibited at Paris's World's Fair in 1889 and was honored with a gold medal. (Paul V. Galvin Library, Illinois Institute of Technology.)

STATUE OF INDUSTRY. On the north edge of the Grand Basin, in front of the Manufactures and Liberal Arts Building, was French and Potter's *Statue of Industry*. Directly across the Basin and in front of the Agricultural Building was a similar statue (*Statue of Plenty*); both were alongside gondola landing areas. Much of the fair's sculptures and statues were made by French and/or Potter. (*Official Views of the World's Columbian Exposition.*)

Eight

AFTERMATH, IMPACT, RELICS, AND LEGACY

During the fair, there was one disastrous fire that destroyed the Cold Storage Building on July 10. The building was used for producing ice for the fair and its concessions. After the fair closed, fires on January 8, the last week in February, and July 5, 1894, decimated many of the exposition's structures. The first fire destroyed the Casino, and its flames also spread to other areas. Arsonists set the July 5 fire, which wiped out half of the Great Buildings. There is some speculation that the July blaze was set by Pullman strikers. By October 1896, a salvage company had removed all but a few reminders of the fair. Over the next few years, remaining structures were also destroyed or were moved to other locations.

The chief legacies of the World's Columbian Exposition were the highlighting of women's issues and accomplishments and, through the efforts of Frederick Douglass, Ida B. Wells, and Paul Dunbar, greater awareness of African Americans' contributions to and exclusion from American society. The presence of foreign nations led to increased international cooperation and trade a few years before the United States became a world power. The role of electricity at the fair increased its use in businesses and homes; the nation's first electric transit system, the L, was used in Chicago during the fair. The planning and design that went into the exposition and the Great Buildings, in particular, led to the "City Beautiful" movement of more civic planning with a focus on improving cities through order and beauty and culminated, for Chicago, in the 1909 Burnham Plan, which had a major impact on Chicago's lakefront that is still evident. The Beaux-Arts and Classical Revival motifs from many of the fair's structures continued to dominate public buildings for many years, and were most evident in cities such as Washington, DC. However, the work of Louis Sullivan and his partner Dankmar Adler influenced and led to a new style of architecture, most notably the later Prairie Style of their apprentice Frank Lloyd Wright, which is in stark contrast to the Beaux-Arts White City.

In 2008, Rebecca Graff, a doctoral candidate in anthropology at the University of Chicago, supervised a dig by undergraduate students in her urban archaeology class. When thinking of archaeology, it is tempting to recall Heinrich Schliemann (Troy) or Howard Carter (Tutankhamen's tomb) or even the fictional Indiana Jones. The fair dig has not found gold but more mundane artifacts of the exposition, such as bottles, crumbled white plaster staff, and gas pipes. The students may have also uncovered the remains of wooden foundations of fair buildings.

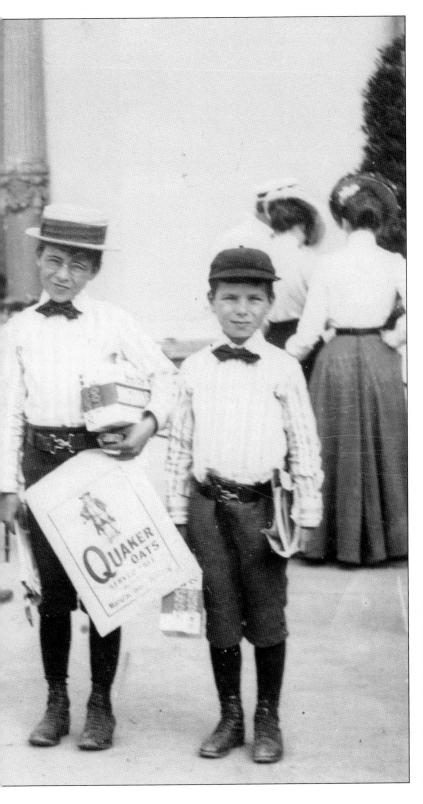

NEW PRODUCTS.
Note the second
boy from right with
a box of Quaker
Oats. Other brands
introduced to the
world at the 1893
World's Columbian
Exposition include
Pabst Beer, Cracker
Jack, and Aunt
Jemima. (Library
of Congress.)

PLAN OF HOLMES' CASTLE, CHICAGO

HERMAN WEBSTER MUDGETT, AKA HENRY HOWARD HOLMES. While fairgoers were enjoying the spectacular White City, Ferris Wheel, and the midway, Dr. Henry Howard Holmes, a graduate of the University of Michigan Medical School, was luring mostly female visitors to a hotel he had specially designed and built at Sixty-third Street and South Wallace Avenue. On the ground floor was his drugstore, but on the upper stories, he arranged a series of windowless rooms where he tortured and killed his victims. A chute sent the bodies to the basement, where Dr. Holmes methodically disposed of them using dissection, acid, cremation, and quicklime. He also sold the victims' skeletons to local medical colleges. Holmes eventually was arrested, tried, and was executed in 1896. The total number of his victims is unknown. (Both, public domain.)

BUFFALO BILL'S WILD WEST SHOW. William F. Cody wanted to perform at the World's Columbian Exposition, but since his request was denied, "Buffalo Bill's Wild West and Congress of Rough Riders of the World" gave two performances a day for the six-month run of the exposition on 14 acres located outside of the fairgrounds between Sixty-first and Sixty-third Streets east of Stony Island Avenue. (Library of Congress.)

ANNIE OAKLEY. One of the sharp-shooting stars of Cody's Wild West Show in 1893 was a young woman from of Tiffin, Ohio, named Phoebe Anne Moses. The world would come to know Phoebe by the nickname given her by Buffalo Bill, "Annie Oakley." She is pictured in 1922, posing with a rifle that Cody had given her as a gift years earlier. (Library of Congress.)

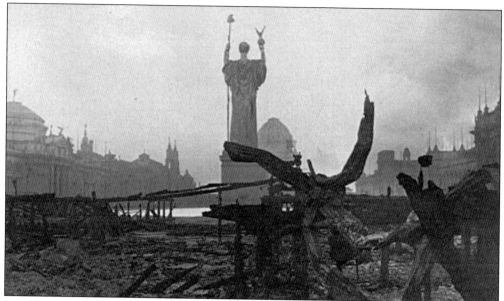

THE PERISTYLE DESTROYED, JANUARY 8, 1894. A fire on January 8, 1894, destroyed the Peristyle, the Casino and Music Hall, and the Moveable Sidewalk. *The Republic* survived but was allowed to fall into disrepair until it was destroyed by a blaze in 1896. The magnificent Great Buildings were lost to fires in the summer of 1894. Three years after the fair ended, salvage companies were tasked with removing all but a few of the structures. (Paul V. Galvin Library, Illinois Institute of Technology.)

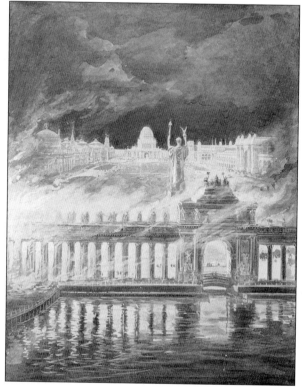

BEGINNING OF THE END. When fires began consuming the fair structures, not all of the buildings' contents had been removed, resulting in the destruction of valuable display materials and works of art. A salvage company, which never had the opportunity to do its work, had purchased many of the remaining structures. The Colonnade burned in late February, and the July 1894 fire consumed the Great Buildings on the Court of Honor as well as the Terminal Station. The German Building served as a restaurant until it burned down in 1925, and the Japanese Ho-o-den was lost to fire in 1945. Many of the fair's statues were relocated to Chicago parks and can still be seen today. Unfortunately, the Golden Doorway of the Transportation Building did not survive. (Paul V. Galvin Library, Illinois Institute of Technology.)

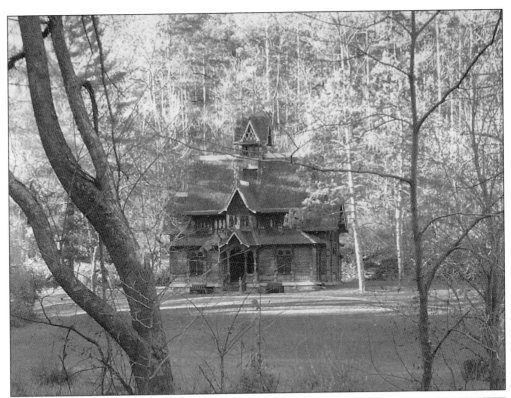

NORWAY BUILDING TODAY, LITTLE NORWAY, BLUE MOUNDS, WISCONSIN. The Norway Building was constructed in Trondheim, Norway, as a replica of a *stavkirke* (stave church). After the fair, it was purchased by a Chicagoan, dismantled, and relocated to Lake Geneva, Wisconsin. Over the years, the building showed signs of its age and, before it deteriorated further, was purchased by the founder of Little Norway and relocated there in 1935. It is one of the few examples of its architectural style outside of Norway. (Photograph by Richie Diesterheft.)

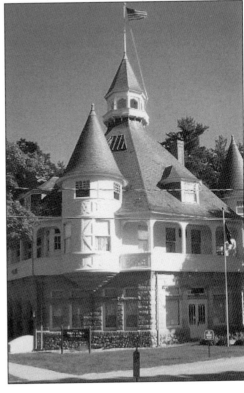

MAINE BUILDING TODAY, POLAND SPRING, MAINE. When the Chicago World's Fair ended, the octagonal Maine Building, designed by Charles Sumner Frost of Chicago, was dismantled and shipped back to Maine, where it was reconstructed at the Poland Spring Resort. The building has been altered since its relocation, with the addition of a third floor; however, this did not change the external dimensions of the original. (Poland Spring Preservation Society & Jason C. Libby.)

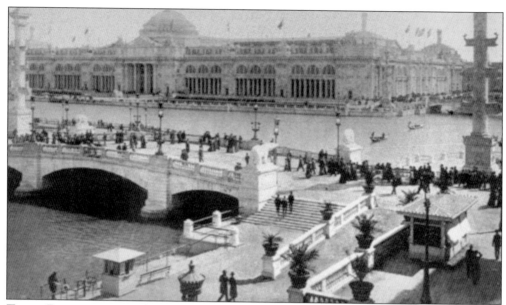

TICKET BOOTH, 1893. In this image, there are two examples of the kiosks used as ticket booths at the fair, one at the lower left and another on the far lower right. Depending on how one arrived, there were several ways to enter the fairgrounds; ticket booths of this type were located at the various entry points near the Lake Michigan Pier, the Terminal Station, and coming off of Chicago streets on the west side of the grounds. (Paul V. Galvin Library, Illinois Institute of Technology.)

TICKET BOOTH, TODAY. One of the ticket booths from the fair can be found in the yard of the Hills-DeCaro House (Frank Lloyd Wright, 1906) in Oak Park. It has had a curious postexposition existence, at one time serving as a garden shed, children's playhouse, and rabbit hutch. After years of benign neglect, the structure is in better condition. (Photograph by David Stone.)

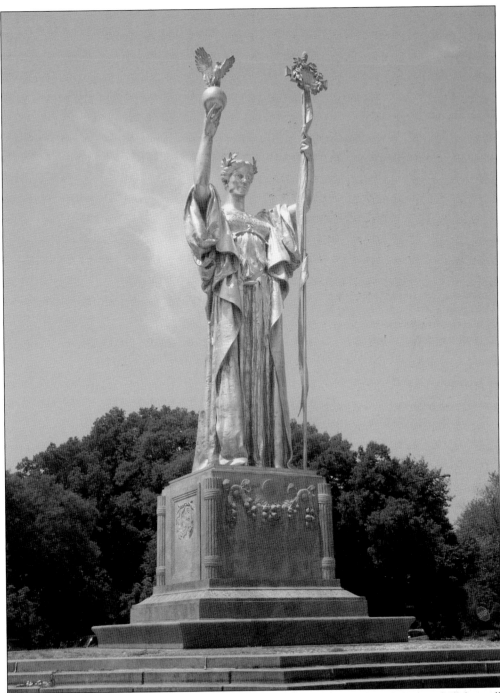

STATUE OF THE REPUBLIC TODAY, HAYES DRIVE, JACKSON PARK, CHICAGO. The original 65-foot-tall statue stood at the eastern end of the Grand Basin during the World's Columbian Exposition. In 1918, to commemorate both the silver anniversary of the exposition and the Illinois centennial, the original sculptor, Daniel Chester French, was commissioned to build a smaller replica of the original. The replica is 24 feet high, made of gilded bronze, and located on the former site of the fair's Administration Building. (Photograph by David Stone.)

Van Houten & Zoon Cocoa Company Building, aka Dutch Building, 20 Netherlands Road, Brookline, Massachusetts. Located behind and dwarfed by the Manufacturers and Liberal Arts Building's northeast corner, the Van Houten & Zoon Cocoa Company was built in the High Dutch Renaissance style, facing Lake Michigan. Holland architect G. Weyman designed the building. The Van Houten Company introduced the process by which cocoa powder was made from cacao beans. Later developments resulted in a powder that was soluble in water. Cocoa powder made it easier to make cocoa and other chocolate drinks as well as solid chocolate for eating. (Photograph by User:Magicpiano.)

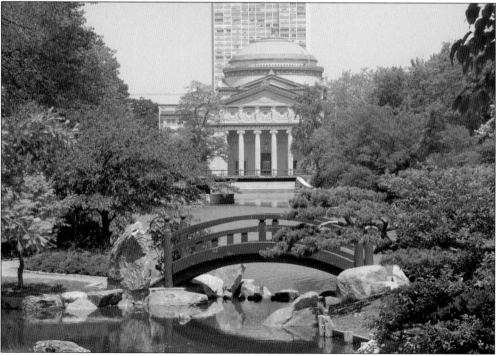

Present-day Wooded Island. The Wooded Island today is the Paul Douglas Nature Sanctuary, where visitors can see a variety of bird species, plant life, and creatures such as beavers, muskrats, and turtles. When Frederick Law Olmsted was designing the grounds for the World's Columbian Exposition, he created the island out of an existing sand dune and surrounded it with a lagoon. Although the fair structures built on the island are no longer there, the Osaka Garden can still be seen. The Wooded Island, with its trails, gardens, and places to rest, serves the same purpose today as it did for visitors in 1893. (Photograph by David Stone.)

MIDWAY PLAISANCE, TODAY. Olmsted and Vaux originally envisioned the Midway Plaisance as a system of promenades and a canal connecting Jackson Park on the east and Washington Park to the west, a plan that never came to fruition. When the World's Columbian Exposition was being planned, the midway became a mile-long area separate from the main fairgrounds that featured exotic exhibits, the first Ferris Wheel, and a host of other entertainments. After the fair, Olmsted's son brought back the idea of transforming the midway into a canal and even excavated for this waterway. However, the canal was never completed. Instead, the Midway Plaisance today is a sunken, tree-lined, grassy, parklike feature transecting the University of Chicago campus. (Photograph by David Stone.)

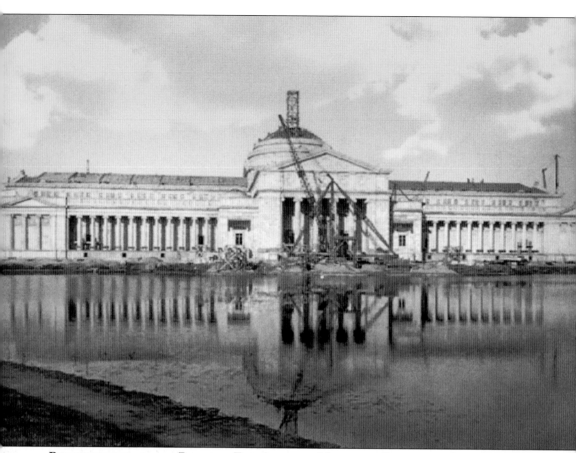

RECONSTRUCTION OF THE PALACE OF FINE ARTS INTO MUSEUM OF SCIENCE AND INDUSTRY, 1930s. After the World's Columbian Exposition closed in October 1893, most of the anthropological and ethnological exhibits from the fair were housed in the Palace of Fine Arts since it was the most permanent structure on the grounds, originally built of brick and plastered with staff. This collection and the building became known as the Field Columbian Museum. In 1920, the collection was moved to the Field Museum of Natural History and the old Palace of Fine Arts was left empty, neglected, and allowed to fall into disrepair. The idea of creating a science museum resulted in the restoration of the 1893 structure. The brick exterior walls were covered in limestone and still retained the original Beaux-Arts look, and the building's interior was converted into a modern style. (Dick Lieber and u505.com.)

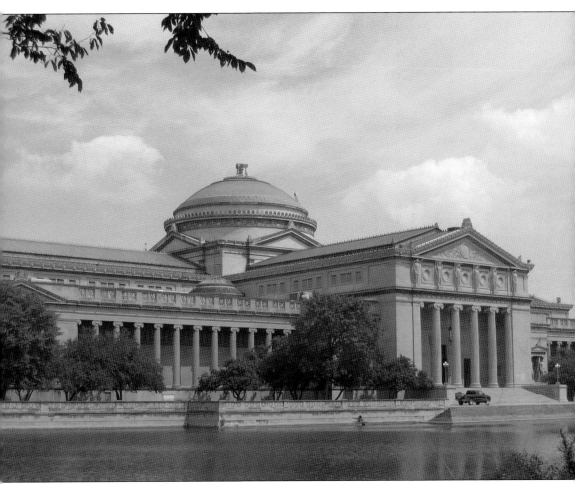

MUSEUM OF SCIENCE AND INDUSTRY, TODAY. The Museum of Science and Industry opened during the Century of Progress Exposition in 1933 and is one of the largest of its kind in the world. Among the over 2,000 static and interactive exhibits, visitors can enter and experience a working coal mine, the captured World War II German submarine *U-505*, and both enter and take a virtual ride on the Chicago Burlington and Quincy Railroad's first diesel, streamlined Pioneer Zephyr. They can also see a 3,500-square-foot HO model railroad that features a scale model of the Chicago Loop and southwest-side neighborhoods around Sixty-third and Halsted Streets, the seaport and scaled model of downtown Seattle, Washington, and representative countryside of the United States between the two cities. (Photograph by David Stone.)

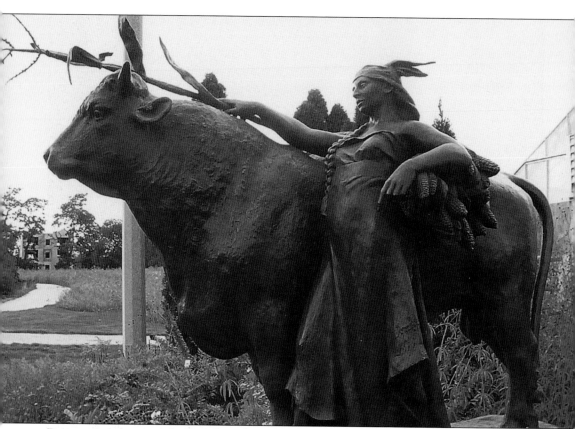

PLENTY. Another group by French and Potter represented the Native American goddess of grain. This figure represents plenty in the form of a Native American holding corn stalks in honor of the native gift of the grain to the New World. This statue, recast as the *Native American Goddess of Corn*, is found in Garfield Park, Chicago, and located west of the Conservatory. (Brian Karpuk, Newsburglar.com, Chicago World's Fair: Remains of the Day, October 9, 2008.)

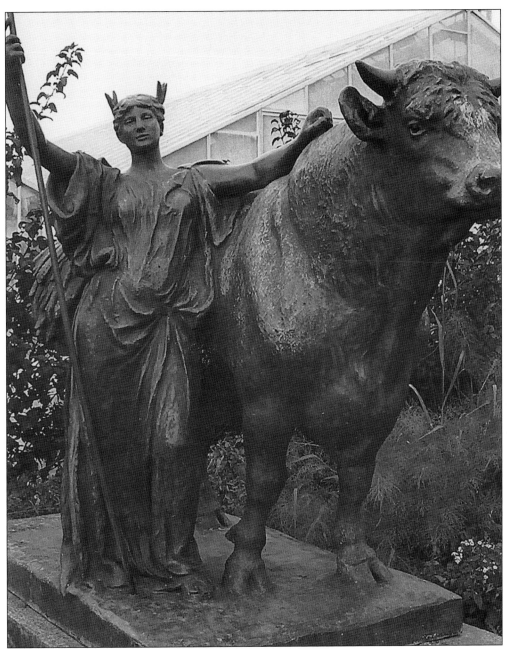

PLENTY. In 1912, this statue was recast as *Ceres, Roman Goddess of Grain*, and today located in Garfield Park, Chicago, and west of the Conservatory. The statues were sculpted for the World's Columbian Exposition by Daniel French and Edward Potter and were originally made of plaster. They were located in front of the Agricultural Building, facing the Grand Basin. In 1909, the statues were moved to Garfield Park and were recast in bronze because of their popularity. The female figures represented plenty in the form of a Native American holding corn stalks in honor of the native gift of that grain to the New World, and of Ceres, the Roman goddess of agriculture. Each of statues is commonly referred to as "Bulls with Maidens." (Brian Karpuk, *newsburglar,* Chicago World's Fair: Remains of the Day, October 9, 2008.)

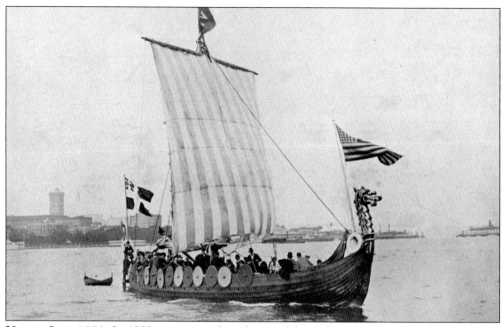

VIKING SHIP, 1893. In 1880, an ancient burial mound from the 9th century containing a ship burial was excavated at the Gokstad farm in Norway. This replica of the Gokstad ship was made in Sandefjord, Norway, and sailed from Bergen across the Atlantic by Capt. Magnus Andersen and a crew of modern-day Norsemen. Arriving at the fair on July 17, 1893, it was moored near the North Inlet. Even though the exposition was in honor of Columbus's first landfall, it was common knowledge among scholars that Norseman had sighted and eventually reached the shores of North America nearly 500 years before Columbus. (Paul V. Galvin Library, Illinois Institute of Technology.)

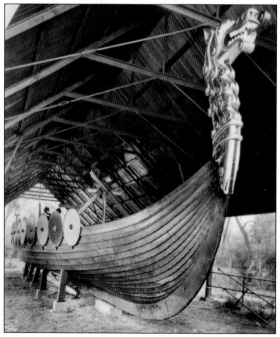

VIKING SHIP, 1920. After the fair, the Viking Ship traveled down the Mississippi to New Orleans, returning to Chicago the next year. It was displayed outdoors alongside the Field Columbian Museum (former Palace of Fine Arts). The ship was poorly maintained and allowed to deteriorate to the point where others sought to repair and restore the vessel. In 1920, it was relocated to Lincoln Park and placed under a wooden shed, fenced off from the public. Due to lack of designated funds, the ship again fell into disrepair; the dragon prow and stern carvings were stored eventually at the Museum of Science and Industry to prevent their destruction. (Lorraine Straw and Friends of the Viking Ship.)

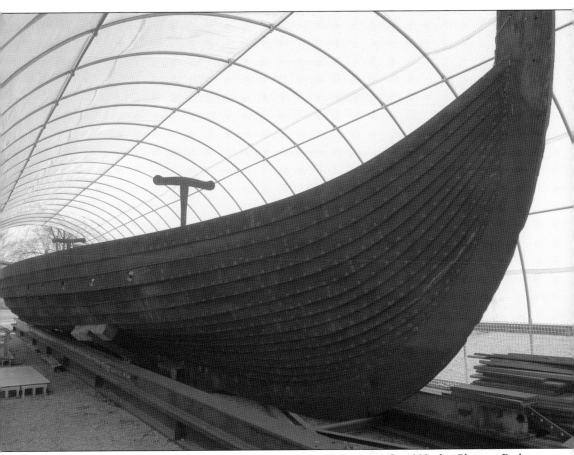

PRESENT-DAY VIKING SHIP, GOOD TEMPLAR PARK, GENEVA, ILLINOIS. In 1993, the Chicago Park District had plans to enlarge the Lincoln Park Zoo and sought to have the vessel moved into storage. In 1994, the American Scandinavian Council purchased the Viking Ship with plans to restore and display it. The ship was relocated to Good Templar Park in Geneva, Illinois, in 1996, where it is displayed under a fabric canopy while restoration and preservation efforts continue. In 2007, Landmarks Illinois placed the Viking Ship on its list of the 10 Most Endangered Historic Sites in Illinois. The organization Friends of the Viking Ship seeks to preserve and find a permanent home for the vessel. (Lorraine Straw and Friends of the Viking Ship.)

COLUMBIAN HALF DOLLAR COMMEMORATIVE COINS (REVERSE, 1893; OBVERSE, 1892). The Columbian half dollar was the first US commemorative coin ever issued. It was released in both 1892 and 1893; the 1892 issue is scarcer. Also in 1892, the US Mint issued a Queen Isabella quarter, a coin that is both rare and expensive. Until the late 20th and early 21st centuries when state and territory quarters were issued, it was the only commemorative quarter. (Di Cola collection.)

COLUMBIAN COMMEMORATIVE POSTAGE STAMPS (COMMEMORATIVE REISSUE, 1992). In 1892, the Post Office Department issued the first commemorative stamps in its history in a 16-stamp issue. In 1992, the US Postal Service celebrated the 500th anniversary of the voyages of Columbus by issuing a set based on those first US commemorative stamps engraved a century before. (Di Cola collection.)

OFFICIAL GUIDE TO THE WORLD'S
COLUMBIAN EXPOSITION; GLIMPSES OF THE
WORLD'S FAIR. Guidebooks are useful at
indoor and outdoor museums, fairs and
expositions, famous buildings, zoos and
parks, and other attractions. There were
many guidebooks and maps published
for the World's Columbian Example of
which this is an example. It cost 25¢ in
1893. Even more popular at the fair were
the many photo albums that visitors
had the opportunity to purchase. This
sample, published by Laird & Lee of
Chicago, claimed to contain images of
the Great Buildings, grounds, all Foreign
and State and Territorial Buildings,
statuary, lagoons, and the Midway
Plaisance. (Both, Di Cola collection.)

RUBY FLASH GLASS AND CUP, COMMEMORATIVE BOX, MEDALLION, SPOONS. Now highly collectible, ruby flash glassware was popular, and many homes used water goblets and wineglasses in this style. Its name derives from the cranberry color on the upper part of the item, created by adding gold oxide to molten glass. Commemorative boxes of either wood or metal and souvenir spoons have always been popular souvenirs. (Di Cola collection.)

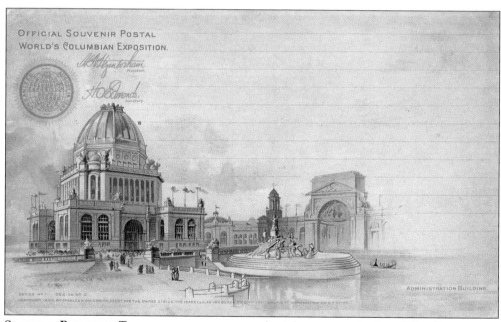

SOUVENIR POSTCARD. To create an easy way to send quick messages, the Post Office Department introduced the first pre-stamped one-cent postcards in 1873. Originally, only that government agency was permitted to print postcards, so private companies called their product souvenir cards. The first souvenir postcards in the United States were issued in 1893 for the World's Columbian Exposition in Chicago. This example depicts the Administration Building on the Grand Basin. (Di Cola collection.)

126

BIBLIOGRAPHY

Appelbaum, Stanley. *The Chicago World's Fair of 1893: A Photographic Record*. New York: Dover, 1980.

Arnold, C.D. and H.D. Higinbotham. *Official Views of the World's Columbian Exposition Issued by the Department of Photography*. Chicago: Press Chicago Photo-Gravure Co., 1893.

Bancroft, Hubert Howe. *The Book of the Fair*. Chicago: The Bancroft Company, 1893.

Bolotin, Norman and Christine Lating. *The World's Columbian Exposition*. Washington, DC: The Preservation Press, National Trust for Historical Preservation, 1992.

Glimpses of the World's Fair: a selection of gems of the White City seen through a camera. Chicago: Laird & Lee, Publishers, 1893.

Hales, Peter B. *Constructing the Fair: Platinum Photographs by C.D. Arnold of the World's Columbian Exposition*. Chicago: The Art Institute of Chicago, 1993.

Harper's Weekly. "World's Fair Supplement." August 20, 1892; March 25, 1893; April 8, 1893; October 28, 1893.

Harris, Neil, Wim de Wit, James Gilbert, and Robert W. Rydell. *Grand Illusions: Chicago's World's Fair of 1893*. Chicago: Chicago Historical Society, 1993.

Ives, Halsey C. *The Dream City: a portfolio of photographic views of the World's Columbian Exposition*. St. Louis: N.D. Thompson Co., 1893–1894.

Van Meter, H.H. *The Vanishing Fair*. Chicago: Literary Art Co., 1894.

Discover Thousands of Local History Books
Featuring Millions of Vintage Images

Arcadia Publishing, the leading local history publisher in the United States, is committed to making history accessible and meaningful through publishing books that celebrate and preserve the heritage of America's people and places.

Find more books like this at
www.arcadiapublishing.com

Search for your hometown history, your old stomping grounds, and even your favorite sports team.

Consistent with our mission to preserve history on a local level, this book was printed in South Carolina on American-made paper and manufactured entirely in the United States. Products carrying the accredited Forest Stewardship Council (FSC) label are printed on 100 percent FSC-certified paper.

MADE IN THE USA